CHARLEVOIX COUNTY, 1930

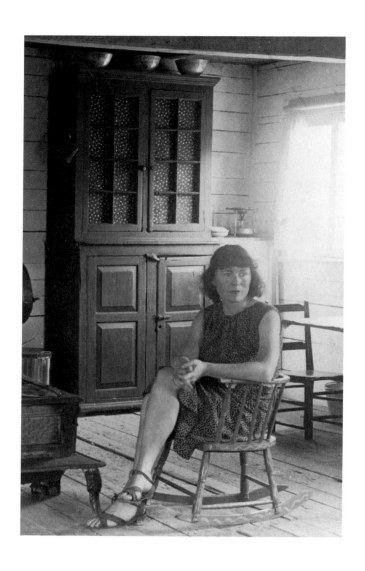

Stanley Cosgrove, *Jori Smith in the summer kitchen of St. Urbain* (Detail), 1936, b/w photograph (48 x 60 cm).
"It was a beautifuil room, large windows on all sides with only a root cellar under the floor to store all our needs."

CHARLEVOIX COUNTY, 1930

Jori Smith

PENUMBRA PRESS

This is a FIRST EDITION published by Penumbra Press
Printed and bound in Canada

CANADIAN CATALOGUING IN PUBLICATION DATA

Smith, Jori, 1907-
 Charlevoix County, 1930

ISBN 0-921254-83-0

 1. Smith, Jori, 1907- --Homes and haunts--Quebec (Province)--
Charlevoix (County). 2. Painters--Canada--Biography. I. Title

ND249.S6226A2 1998 759.11 C98-901342-1

CONTENTS

Acknowledgements 6
Preface 7

Spring & Summer, 1930 9
Autumn & Winter, 1931 14
Winter, 1932 17
Spring & Summer, 1935 31
Autum, 1935 39
Winter, 1935-36 47
Spring & Summer, 1936 58

Postscript 93

Plates

Stanley Cosgrove 8
Alicia Johnson 92
Jori Smith 97
Jean Palardy 102
Simone Mary Bouchard 110

ACKNOWLEDGEMENTS

The publisher acknowledges the editorial contributions of the following:
Dinah Laprairie, Sharon Hamilton, Kathryn Fournier, Anna R. Dillon
Brennan, and Naomi Jackson Groves, all of whom read earlier stages of
the manuscript in preparation for publication; and the typographical
expertise of Stan Bevington and Chris Lawson.

Original photographs by Stanly Cosgrove, Alicia Johnson, and Jean
Palardy. Photographs for reproduction by Maria Horyn, and Brian
Merrett Collectoions Imaging, Montreal,
http://www.cam.org/-lymerre/fineart.html

The author and publisher also thank the contributions of
Talbot Johnson, Dr. Joseph Stratford, Naomi Jackson Groves, and
Galerie Dominion for their generous support of this project.

DEDICATION

For P.K. Page, and Charlevoix friends, with love.

PREFACE

Although this delightful narrative covers only part of a ten year period in the life and long career of artist Jori Smith, she and her husband, Jean Palardy, after purchasing a home at Petite Rivière, Saint Françcois, and establishing a studio on Ste. Famille Street in Montréal in the early 1940s, made new friends and went on with their lives and careers.

Jori, who celebrated her 90th birthday on January 1, 1997, never kept an extensive diary of the events at this time. However, from the memories she has recorded here one can glimpse not only the difficulties and hardships but also the joys and celebrations that dominated the lives of the residents of Charlevoix County in the 1930s.

"It is not about my life, it's about what I witnessed in Charlevoix County in those very important years from 1930 to 1940. I'll tell you why they were important. They [the residents] were living exactly as in the eighteenth, seventeenth centuries, like their parents and like their grandparents ... away, isolated up in the mountains, where we spent two winters just with the people, living as they lived ... we were the only ones who did this. The war and the advent of radio abruptly and drastically changed this way of life forwever."

— Excerpt from a taped interview with Jori Smith, Montréal,
 May 25, 1996. *Anna R. Dillon Brennan, Ottawa*

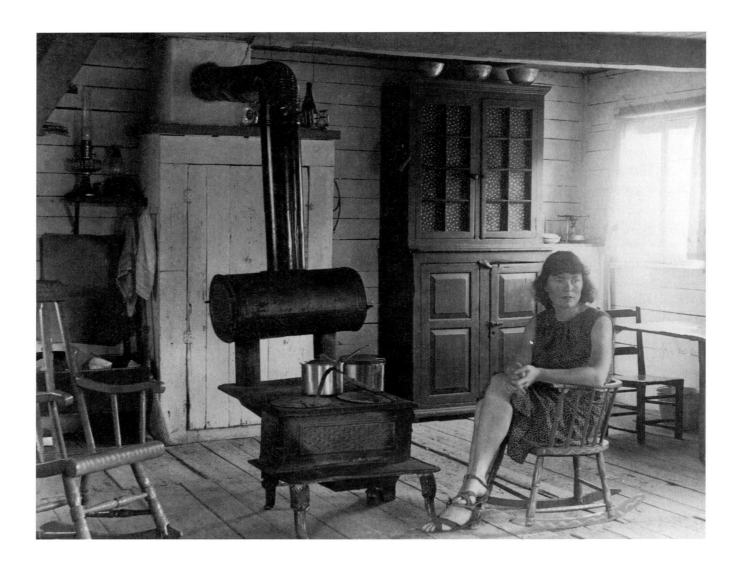

Stanley Cosgrove, *Jori Smith in the summer kitchen of St. Urbain*, 1936, b/w photograph (48 x 60 cm). "Stanley was staying a short while in Baie St. Paul and got a lift up to St. Urbain to visit us. I don't believe he was painting on that occasion, just curious to see how we lived. That armoire was one of the first pieces of furniture we bought, not particularly because of its beauty but because we needed it. That is how we began our extraordinary collection and Jean's passion for antiques."

SPRING & SUMMER, 1930

WHEN WE CAME TO CHARLEVOIX COUNTY in 1930, Baie-Saint-Paul was hardly more than a village, sprawled in haphazard fashion near the St. Lawrence River. A small tangle of twisting, narrow streets, the hamlet lay at the broad base of a triangle of land formed by the valley of the Rivière du Gouffre, so named after the salmon river that flowed in graceful curves through its center. At the end of the valley, mountains towered above the settlements, taller and more imposing as they met and joined together at the tip of the triangle.

It was to these mountain tops that one looked for the first and last traces of winter, their peaks white one month before the snow came to stay down below and long after Spring had taken hold in the valley. To our eyes, long accustomed to urban landscape, the valley appeared an oasis. Girdled by fir-treed hills, the plain was sheltered from violent winds and favoured by the power of the hills to draw rain from the clouds, so that summer storms, though brief, were frequent.

The soil was rich and black, and generations of farmers had grown prosperous from its bounty. Their houses, massive fieldstone structures strung along the lowest slopes of each side of the valley, had been built to endure for centuries. The barns, too, were immense and solidly-built, their ample proportions symbols of plentiful harvests. In some places, the fields and meadows sloped gently down to the tree-shaded shoreline, in others, ending abruptly at the edge of the cliffs overlooking the river. In Spring, farmers owning land on these cliffs would often glumly watch huge slices of choice land crumble and slide away forever in the tumbling waters. For this reason, these acres were used for raising grain.

In summer, the valley floor became a sea of green, appearing to flow alongside the river all the way down to Baie-Saint-Paul, cascading uninterrupted save for the fences meandering crazily across the fields, delicately setting off swaths of endlessly varying shades of green. As autumn approached, and the last of the fields had given their harvests, the bright colours of summer would yield to those of a gentler kind, as though the valley were pulling over itself the remnants of an old blanket.

In the village itself, there were three large buildings, the church, the convent, and, largest of all, the insane asylum. The asylum was run by the nuns, who also owned and operated a vast farm in the very centre of the Baie. At the time, this asylum was one of the most important of its kind in eastern Canada, and its inmates came from all parts of the country. Since there was but one doctor to serve the entire parish, including the asylum, the inmates were given no treatment for their physical problems, other than the most rudimentary kind. When we queried the doctor about this, he dismissed our concerns good-naturedly, assuring us that the nuns were quite capable of ministering to them. He, of course, had no time to waste on idiots; other than pulling out their teeth if they became too unmanageable. "Ils sont tous fous. Il n'y a rien à faire pour eux." Our expressions of interest in the inmates' welfare provoked only amusement — and patronizing amusement, at that — from the doctor. He related the story of a French doctor ("un français de France") who had come hundreds of miles to visit and inspect the asylum. "Il a tout vu, il est allé partout, et savez-vous ce qu'il m'a dit en partant?" He threw back his head and laughed. "Il m'a dit, 'Docteur, quels trésors vous avez là!' Des trésors? Imaginez-vous ça!"

The nuns' farm was operated by a work crew of inmates, those who were capable of understanding simple orders. We used to pass them on the street as they tramped in columns to and from their labours. The similarity of their features and their gestures never failed to amaze us and

arouse our pity. Their round heads appeared fastened directly to their shoulders, unable to turn either to the right or the left. Dressed in grey overalls, their skulls close-shaven, they shuffled along, like lifers on a chain gang, long since dehumanized beyond any awareness of their pitiful circumstances. Were they uncomprehending, we wondered. Perhaps they considered themselves fortunate, compared to the misery endured by the other inmates, many of whom never left the confines of their cells, some even chained to their beds, seeing only their keepers until they died.

Many of the occupants of this huge building, which was six or seven stories high and formidable in its severity and ugliness, had been born in the village or in the surrounding concessions. The unusually high number of mental defectives in the region was attributed to an incident many decades before. According to a local legend, a steamer carrying a large troupe of second-rate actors and actresses from Paris had shipwrecked in the bay, and the survivors had been cared for by the villagers. Unfortunately, before the convalescing thespians were well enough to move on to their engagements in Montréal and Québec City, some of them managed to infect more than a few of the villagers with syphilis, thereby launching an epidemic which was to have tragic consequences for future generations of Charlevoix families. In time, the disease — called "le mal de La Baie" — would spread throughout the entire County, and rare were the families who were spared its effects. Decades later, memories of the epidemic still wielded a macabre power over the thoughts and fears of the region's inhabitants. In fact, it was not uncommon for a mother to acknowledge a compliment on the beauty of her child with this swift and anxious reply: "Il a tout son esprit, au moins."

During our years in Charlevoix County, we got to know many such abnormal children, watching them grow to adulthood, for many were loved and cherished in their own homes. Only the most difficult and hopeless cases were relinquished to the local asylum. In the nearby vil-

lage of Saint-Urbain, there was a family whose children, boys in their teens at the time, were all mentally impaired. It was a strange sight indeed to see them, late Sunday afternoons, walking in single file down the long hill on their way to vespers, their black stove-pipe hats resting at rakish angles on their ears. Like the nuns' labourers, they stared straight ahead with vacuous expressions, neither diverted nor aroused by anything around them. Often passing their house, we would see them seated motionless in a row along the verandah, dangling their fishing lines into the garden below. In a way, they seemed almost happy.

During our first month in Baie-Saint-Paul, we rented a tiny upper flat belonging to Wilbrod Simard, a jack-of-all-trades who lived below us with his small family. Just under our narrow verandah was the chicken coop, the source of a most pungent and disagreeable odour. The chickens were a source of considerable amusement. We would spend hours hanging over the verandah railing tossing them our kitchen scraps one morsel at a time, laughing at their agitated pottering about. Unfortunately, this harmless pastime of ours found little favour with our landlord, Monsieur Wilbrod, who seemed convinced that all this violent exercise was going to toughen the flesh of his hens. So, when we told him one day that "circumstances" forced us to look for other lodgings, he appeared not at all dejected or insulted. That is, until we explained the very circumstances which had precipitated our decision — the army of bedbugs in our flat. Thinking back on it, of course, we could see that a strong, pervasive odour had been there all along, and in our ignorance, we had simply put it down to the mustiness of long-shut windows. Several weeks of circulating fresh air through the place day and night had given us no relief from the odour. It was only when I consulted a local doctor about the red bites covering my body that the cause became clear, and an examination of the bedsprings confirmed it: bedbugs! Monsieur Wilbrod's reaction to this revelation was one of surprise. Oh, not surprised that the bedbugs

were there; surprised only at what he considered our dramatic response to them. After all, he assured us, bedbugs were as common and as harmless as houseflies, perhaps a bit more annoying, but one simply learned to live with them. Slightly offended, he admonished us: "Tout le monde en a, même les gens de la ville. Tenez, mon frère à Montréal, sa maison en est pleine." Seeing that our minds were made up, he took with amiable grace our decision to move immediately, even offering to help us find another flat.

AUTUMN & WINTER, 1931

WE SPENT THAT FIRST WINTER in Baie-Saint-Paul most pleasantly, getting to know a great many people, for we skied cross-country in all directions. Sometimes on these outings, we'd carry a lunch, but more often than not we'd stop at some farmhouse, where we were always urged to join them at their meal, even if it was only fresh-baked bread and molasses (as it often turned out to be in the poorer concessions).

A great many of these small farmers were poor, their lives as barren as the land around them materially, but not poor in spirit. Far from it. How I envied them their spirit of love and concern for one another. These large families had nothing beyond what they could drag out of a recalcitrant land, but they were together and they were happy, even gay. We came to like these people of the poor concessions so much that, in the Spring of that year, we went to live high up in the mountains in the concession of La Misère between Baie-Saint-Paul and Les Eboulements.

IN LA MISÈRE, we boarded with a family named Aquilas Girard, an unusually small family for that time — the parents, two homely daughters in their twenties, born of Aquilas' first marriage, and a sickly little creature named Cécile, the offspring of his second marriage.

The concession of La Misère was aptly named. The fields behind the house were dotted with half-submerged boulders and, here and there, pyramids of rocks painstakingly assembled as each year's ploughing unearthed new ones. Beyond the fields, an apron of low shrubs rimmed the woods, which Aquilas had gradually thinned out over the decades. Next to the house itself was the vegetable garden, solely Madame's

responsibility and a testament to her diligence and optimism, for all sum-
mer long the vegetables strained and struggled in that uncharitable soil.
There were three cows, but the family kept back only a small portion of
their output, preferring to sell the cream and most of the milk to the local
cheese factory. There were also a dozen or so hens. One Sunday a month,
one of these pullets was sacrificed for the big meal of that week. In
between times, we ate eggs, eggs, and eggs.

Farming here was much harder than it was down on the lush, fertile
valley floor. Here everyone was poor, so our own poverty went virtually
unnoticed. In retrospect, it seems incredible that we were charged only $4
per week for room and board — and this for the two of us. How on earth
could these people have managed to make any profit at all from us? Yet
they seemed delighted to have us with them, even grateful. Aquilas even
built us a small room in the attic so that we could have some privacy.

ALL SAINTS' DAY, a pig and a calf were killed, quartered, and hung to
freeze in the summer kitchen. The butchering was done in the yard, and
I remember the lurid red of the blood splashed here, there, and every-
where against the snow. The liver and other organs were consumed
immediately — and how delicious they tasted after a long, meatless sum-
mer! — and the blood carefully collected to be made into pudding. The
butchering took the entire day. After the animals had been slaughtered
and the organs and hides stripped away, Aquilas set about chopping,
hacking, sawing, and slicing the meat into sections. The three girls, their
aprons bloodied, rushed back and forth between their father outside,
deep in gore, and their mother, perspiring and flustered, boiling up the
blood pudding on the stove. The poor cat was so distracted by this sud-
den windfall of goodies that he couldn't make up his mind where to start,
so he ran from one delicacy to another until all had disappeared. The
work done, we sat down to a meal of liver and the trimmings, looking

ahead to those countless winter suppers of pork and veal, served with heaping platters of turnips, carrots, and potatoes. Only our citified craving for fresh fruits and salads would go unassuaged.

That autumn of 1931, we witnessed one of the last corvées of the beating of the flax. It took place in a small sheltered clearing in the woods on land belonging to one of our neighbours. A festive occasion it turned out to be, too, with all eight or nine families of the concession taking part. The flax was brought to the clearing in hay carts, as were the special handmade troughs, each equipped with long bar handles, which were used for beating the flax. The long sheaves of flax were placed across the hollowed-out top of each trough and held in one hand, while the other hand lifted the handle up and down in order to break and pulverize the chaff, which then blew about in all directions, leaving behind only the fine threads of flax. Once the troughs had been placed in a large circle allowing ample room for movement, we set to work with high good humour and zest. The children scurried back and forth, keeping each of us constantly supplied with sheaves of flax and gathering up what had already been beaten. It was all so gay and colourful. Adults and children alike were dressed in their oldest homespun clothes, faded to gentle washed tones and now uniformly dusted with the delicate debris of the beaten flax. Behind us like a giant curtain were the deep green pines, their colour darkened by contrast with the silvery stands of birches in their midst. We sang a great deal throughout the day, marking rhythm with the beating of the handles, stopping work only long enough to gulp down a bit of bread (baked the day before in Madame's outdoor oven) slathered with butter. The sun was setting when, the last of the flax beaten, we packed up and walked home.

WINTER, 1932

DURING THE WINTER, MADAME and one of her daughters would sit by the window and spin, while upstairs in the attic the other daughter would spend hours at a time bent over the loom, weaving bolts of linen from which they would later make sheets, towels, and dresses. Winter was the ideal time for such work. Every day but Saturday and Sunday, the spinning and weaving would go on until the afternoon light failed, interrupted only for the most essential household chores and the preparation of and eating of meals.

As winter came on, Aquilas would spend more and more of his time rocking beside the stove and smoking his pipe, the spittoon handy at his feet and the wood box only an arm's length away behind the stove. The kitchen, which served as the family's principal living quarters, stretched the full width of the house. It was a cheery, low-ceilinged room, and the four windows plus the windows of the door brought in the maximum of sunshine all day long. The floor, or what one could see of it, had been painted a vivid orange, which was decoratively crossed by several wide runners of gaily-striped catalogne. In front of each of the three bedroom doors leading off the kitchen was a small braided rag rug of lovely primitive design. Dotted muslin curtains framed the windows, and on their ledges were pots of geraniums. The walls were painted a soft sage green. At one end of the kitchen, a very steep and narrow staircase with a thin strip of catalogne running up the middle of it led through a trap door to the attic.

This description could have been applied to all the little farmhouses we visited in the concessions during our stay, and it remained so for

many years thereafter. I well recall the jolt of pleasure I felt the first time we entered one of these interiors. That such unsophisticated, untutored people could have such pure and perfect taste in their decorative objects was a revelation to me, all the more surprising considering their drastically limited resources. What little money they managed to accumulate — "de peine et de misère" — had to go for such essentials as molasses, sugar, and salt. Objects of beauty for the household were also objects of necessity, which they were obliged to create with their own hands and their own ingenuity, following traditional designs and patterns handed down from one generation to another. Many years later it was a source of great sadness to watch as increasing prosperity and contact with the "modern world" seduced them into abandoning these old ways. In barely more than a decade, many of the ancient cultural traditions, in all their beauty and simplicity, had felt the onslaught of radio, television, and the automobile, and were replaced by a taste for all that was worst in modern design. It seemed to us as if these people of the 18th century had been hurled, unprepared but unprotesting, into the 20th century. How fortunate we were to have been among the only ones of our generation — surely no more than a handful — to witness first-hand that era of innocence, which we knew, even then, would soon disappear forever.

To our neighbours and our new friends in Charlevoix, we were, to say the least, exotic. Especially me, "une anglaise." (Though I continually made a point of emphasizing my Irish blood, thinking it might be more acceptable than my English, they continued to refer to me as "l'anglaise.") Not only was I a pagan, but I spoke a kind of French which must have struck them as bizarre. At that time, I had only just begun to decipher the accent and the picturesque idiom of the Charlevoix countryside. How grateful I was to become later on for this challenging experience, for because of it I was able to understand the French spoken anywhere in the province.

I was also a curiosity and an object of pity to them because, although married six months, I showed no signs of pregnancy. Pauvre madame. Poor madam, indeed — poor them! Never had I seen so many pregnant women. In nearly every house we entered, there would be a woman either recovering from a lying-in or about to produce at any moment. How casually they took these events! When the moment of labour would arrive, the smaller children would be packed off to the nearest neighbour and someone would run to fetch the midwife, who often arrived after the baby did.

Often, too, the baby would die. And in the many cases that I witnessed, no great regret was ever expressed. They all had so many children — fourteen, fifteen, or more was common — that if a few died now and then, well.... As they saw it, after a proper christening, the baby would go off in a white box to join the heavenly chorus of sisters, brothers, and cousins. Tragically, a great many of these babies died from exposure, thanks to the curé's insistence that baptism take place within a few hours of birth — whether in the wildest thunderstorm or the most frigid winter night, the newborns had to be taken to the church for christening. How any of them survived is quite beyond me. And that goes for the mothers, too. In those days, death in childbirth was not an uncommon fate for a woman. It was unthinkable, of course, to fetch a doctor for such a natural occurrence. Even if the family had had the money to pay for his services, there were no telephones for miles around and the doctor invariably lived too far away to have a hope of arriving in time to be of much use. The first wife of Aquilas had died this way, giving birth to the younger of the family's two daughters. His second wife Maria, after three or four miscarriages, brought Cécile into the world and then became sterile — which no doubt made her the envy of at least some of her neighbours.

There were so many children that every concession, even the shortest

of them, had its own little schoolhouse, a one-room affair always packed with very young children. As a rule, schooling lasted only two or three years at most, just long enough for them to learn their catechism, little else. The teachers, almost always young ladies from Baie-Saint-Paul, stayed in the concessions during the school year, boarding at one of the farmhouses. The privilege of boarding the schoolmistress was the subject of much rivalry, it being considered an honour to share one's home with a creature of such superior breeding and education. At veillées, the young men would vie with each other for the chance to sit next to "la maîtresse d'école." And it was understood that one of them would marry her, or at least become engaged to her, before she returned home for the summer. It was rare indeed that a young lady would fail to find a husband on her first job. It didn't matter at all whether she was attractive or not. Being the schoolmistress was apparently enough, and most of them learned rather quickly to use to their advantage the prestige which their status conferred. In return for the money she paid for bed and board, barely a token amount, the schoolmistress was treated as a privileged guest, never asked, nor allowed, to share in any of the daily household chores.

La Misère concession, high above the St. Lawrence River, was a bare and windy roller-coaster of land, with a conspicuous absence of trees, except for the low-lying clumps of brush and vegetation bordering the pasture land behind the houses several fields away. The houses, all built close to the road, were separated by considerable distances, so that a woman would think twice before running over to the neighbours to borrow a cup of sugar. Poor as the people were, they owned acres and acres of land, stretching all the way down to the river and for at least a half mile beyond their houses in the rear. During the winter, they gleaned wood from their own forests to sell and to heat their houses. In the spring, they tapped their own ancient maple trees, which grew tall and straight in thick formations down by the shore.

I recall with great pleasure a long delightful March day we spent there, watching the family dash from tree to tree, from bucket to bucket, while Aquilas tended the fire and stirred the syrup. I have never forgotten that long climb back up the mountainside in the calm and poignant beauty of that early Spring evening, nor the deep glow of happiness and serenity that shimmered within me for hours thereafter. Over the years, my thoughts have often turned back to that moment of strange and rare ecstasy.

During the long winter months in La Misère, there were veillées almost every night of the week in one or another of the houses on the concession. These were important occasions, not to be missed, and few wished to be left out. As soon as the supper dishes were cleared, whole families would arrive with their infants, toddlers, teenagers, grandparents — anyone and everyone who wasn't bedridden. Beds would be heaped high with coats, tuques, and shawls. In the chilly bedrooms, drowsy babies were nestled down among all the wraps, where they would continue sleeping throughout the long evening, in spite of the raucous singing, shouting, stomping, and general din of the games and the square-dancing. How these people thrived on noise! Eventually, I got used to being shouted at, even when at close quarters and when there was no real reason for it. They did not talk; they shouted, and quite often all at the same time. It was a habit they had no doubt acquired from long days in the fields directing their oxen and horses. Then, too, perhaps in such large families, shouting was the only way to make oneself heard.

We were virtually enveloped in a sea of sound, which would only die down to a hush when one of the guests would be invited to sing a solo. Then, the older men, who had been huddled together over their pipes talking, would abruptly straighten up and lean their chairs against the wall to stare at whoever was about to entertain them. The tribe of smaller children, crushed together on the stairs leading to the attic, would be

sternly hushed, and the courting couples would momentarily cease their mutual self-absorption. The singers would invariably begin their performances by grasping the top of the closest chair with clenched fists and throwing back their heads; once so braced (against what I was never sure), they would bellow out a ballad, complainte, or a simple love song as loudly as possible. This was all done quite unself-consciously, as though it were tacitly understood by all that the singers had a duty to perform and they were giving it the best they could. We would all listen in respectful silence. Typically, when the last note had been sung, the singer would drop, exhausted, into a chair, murmuring, "excusez-là," to which we would reply "marci," whereupon everyone would immediately turn back to whomever they had been talking to before the interruption.

During the festivities, I found myself spending most of my time looking at (I should say, spying on) the lovers. Never before had I seen courting rituals such as these. Try as I might, I never did discover how the seating arrangements came about. I was dying to know, because it became apparent that the boy's or girl's fate in the marriage market depended a great deal on whom they sat next to at these veillées. This was virtually the only opportunity they had for courting; never were they allowed to see each other alone. Only on chaperoned occasions such as these were they able to sit close to each other, crowded together on the narrow benches lining the walls, so close that their thighs, legs, and arms touched. I was only able to observe their profiles, for they would gaze raptly into each other's eyes all evening, their noses almost touching, murmuring solemnly, intensely, mysterious things beyond even my efforts to overhear. Whenever the lovers were asked to sing, they would leave off mesmerizing each other and, without protest, stand and deliver. It was the tradition that when the same boy and girl had sat together on one or two such occasions, they were engaged (often without any declaration) and would marry in the spring.

In those days, sexual encounters before marriage were virtually unheard of in Charlevoix County. Only once in all our years there did I ever hear of a young man having to marry a girl because of a premature pregnancy. It was in the concession of La Décharge, six or seven miles from the village of Saint-Urbain. It was the custom then, before the wedding, for the parents to allow their daughter's young suitor to spend an evening with her now and then during the week. Since tradition also decreed that the young couple had to be chaperoned, these evening visits were an onerous chore for the parents, particularly during the summer, for they would most likely have spent sun-up to sunset toiling in the fields. Sometimes, when it was the mother's turn, she would pass the hours knitting and rocking at a discreet distance from the whispering couple. Try as they might to escape the mother's watchful eye by huddling together in the shadow of the staircase, they would never succeed.

But one night — in the case of our impetuous suitor from a neighbouring concession — it was the father's tour of duty. After a day of haying in the hot sun, he soon relaxed his guard and fell sound asleep. It was his daughter who shook him awake much later, after her young lover had gone. Gone for the night, but not gone forever. Next season's haying season found him working in the fields alongside his father-in-law, only too glad to fall into bed with his young wife and tiny baby as soon as supper was over, his energy for amorous pursuits after dark considerably stifled.

Such cases of divergence from the social and sexual norms were extremely rare only because parental, indeed community, vigilance was so rarely relaxed. Not only were young adults of courting age chaperoned, even much younger children were closely watched for signs of sexual experimentation, even if they were siblings. One Spring day, I was sitting in a kitchen chatting idly with an old woman and her daughter-in-law. The two youngest children of the house, a girl of 11 and her brother of 9, were playing in the barn close by, their shouts and laughter floating

in through the open window. Suddenly, the noise ceased. When the silence from the barn had lasted quite some time, the old woman stopped ironing and, turning to her daughter-in-law with a meaningful glance, said, "Tu ferais mieux d'aller voir ce qu'ils font."

Since the illegitimate sexual act was considered the greatest of all sins, early marriages were encouraged. And virtually inevitable for all — spinsters and bachelors were rare indeed in Charlevoix County. No matter how plain the girl or how ugly the man, they always managed to find a mate at one of the veillées, usually in their own concession or — "faute de mieux" — in the next one. How terribly matter-of-fact and unromantic these courtships seemed to me. Even the Puritans of New England conceded to reality by allowing young lovers the "bundling board." But young lovers in Charlevoix County were allowed almost no opportunity for cuddling, wandering hand-in-hand in the moonlight, or necking in the barn.

That winter, we went to all the veillées, at least two or three a week. They never failed to amuse and instruct us; what we were experiencing was a fast disappearing way of life. We became part of that tiny community, and the affection we felt for its people seemed to be reciprocated. We danced with them, supped with them, sang with them, shared so many simple and innocent pleasures. So full was our social life that I don't believe we read at all that winter, which was most unusual for us. Our evenings were spent sitting about kitchens socializing. In time, I leaned to sing their beautiful 18th-century ballads and complaintes and was very proud of myself when I finally mastered tap-dancing ("gigue"), for that meant that I, too, could stand up and perform at the veillées. All the spontaneity and extroversion which seemed to come so naturally to the people of the region suited me perfectly, so that I fitted in as though born there and was exceedingly happy.

Countless times during our stay in Charlevoix County, we witnessed a philosophical acceptance of calamity. Life had always been difficult for

these people — "on se l'arrache le diable par la queue, et depuis toujours" — and inured them to hardship. Things could always be worse. Once we watched a child die of tuberculosis just down the road from us. During her long, debilitating illness, no doctor had ever been sent for and no special care was ever given her. All day long, she would sit in the kitchen, only rarely summoning the energy to drag herself out onto the verandah to sit in the sun. When she died, there was no mourning, no lamentations. Her mother said only, "Elle est ben mieux au ciel, elle ne souffre plus." At that time, many people of all ages, not only children, were dying of tuberculosis. There was no knowledge of hygiene, and infections would sweep through entire families. Often, the culprit was the communal drinking cup used in the homes and the schools; it hung next to the pump or the tap and was rarely washed.

Coming as we did from the city — and from the 20th century — there were many kinds of information and advice that we would have gladly shared with our new friends and neighbours to help them improve their living conditions. But, despite our concern and good intentions, helping them in this way proved to be difficult. Our advice and counsel could so easily be dismissed as suspect because we were so different from them. Despite the friendliness they unfailingly showed us, we were strangers. We appeared decent enough, that was true, but we didn't practise their religion, we didn't dress the way they did, and we didn't have children. Had we been somewhat less bohemian and exotic in our ways, perhaps these cordial but conventional people would have been more receptive to our desire to help them.

This was brought home to me rather forcefully one time when I tried to help one of our neighbours, a young married woman who had just given birth to her third or fourth child. When she broached the subject of birth control with me (because I was childless, I suppose), I leaped at the chance to tell someone at last about the rhythm method, which was then

permitted by the Church but never publicized outside the large urban centres. Nowhere in Charlevoix had I ever met anyone who had heard of it as a way to plan family size. Not realizing the hot water I was stepping into, I told my young neighbour all I knew about the method. The very next Sunday, the parish priest denounced me from the pulpit before the entire congregation, reviling me as a creature sent by Satan and warning his parishioners of the danger of befriending me. Fortunately, I had made many friends by this time, and, as no one really liked the curé or took his advice seriously, the affair came to nothing. Though we continued to live harmoniously with our neighbours, this had been a lesson to me: never again would I give advice on birth control.

Being a non-believer myself, the attitudes of these people toward religious authority never ceased to astonish me. For them, the parish priests were infallible parental figures, who could do no wrong. Even if they were disliked, and this was sometimes the case, the prestige the Church conferred upon its shepherds inspired profound respect, even awe, among the flock. To be sure, the curé's advice was sometimes disregarded by parishioners in the grip of strong appetites, but so powerful was authority of The Word that such acts of deviance were usually rationalized ("Monsieur le curé ne peut pas comprendre ça, il n'est pas marié ... ") and accompanied by feelings of guilt. Wrapped in his cloak of divine authority, Monsieur le curé was practically invulnerable, almost to the point of being above the law in certain cases. I was once told of a parish priest from the concession of La Misère who, while returning home from a hunting trip, ran over and killed a child. The child's mother saw the accident and ran out of the house, screaming and shouting in great distress. The curé, who was at that moment dressed in his hunting clothes, got out of the car and went over to the distraught woman. Stifling her cries with a gesture of his upturned hand, he said peremptorily, "Attendez un moment, madame." Calmly, he reached into the back seat of his car,

pulled out his cassock and slipped it on. Then, turning once more to the dead child's mother, he said, "Parlez maintenant, si vous voulez." At once, the poor woman threw herself at his feet and began praying. Monsieur le curé was, of course, never prosecuted.

Among the people we enjoyed visiting during our time in Saint-Urbain were the Bouchards (a common name in the area). The family's young daughter, Mary, was later to become a well-known primitive painter, whose work nowadays fetches big prices. The Bouchards lived in an old grain mill, built originally by their ancestors, and Mary's father still ground the corn and wheat according to the traditional ways.

All the Bouchard children were exceedingly pretty and very old-fashioned in their ways (even for those days), not only in their dress but in their gentle, refined manners as well. The family never left the isolation of their life at the mill except to attend Sunday Mass, and, apart from the farmers' seasonal visits, only rarely did anyone go there. It was not an easy place to get to, in any event; one could not just drop in. Perhaps because of this isolation, the Bouchards had become sufficient unto themselves and were quite obviously contented with one another's company. The children of all ages were little angels, and Mary, the eldest at 17, was adored by the entire family. She kept them endlessly entertained with games of her own invention, and there always seemed to be something going on around the Bouchard place.

Typical of most French Canadian households of the time, the hub of activity in the Bouchard house was the kitchen, a spacious, sunny room with low-beamed ceilings and deep-set square windows, whose ledges abounded with a charming array of flower pots, school books, and small children. At the farthest end of the room, Madame Bouchard would spend her afternoons sitting at her loom, which remained set up all the year round, the youngest of the children playing at her feet.

Whenever we dropped in for a visit, the children would come tearing

down the stairs from the attic to greet us, the noise of their chatter and laughter all but drowned out by the roar of the water wheel and the milling machinery in the next room. How extraordinarily glad they always were to see us. One of them would rush off to fetch Papa, while others would seize our wraps, dashing off to hide them in case we might be thinking of making only a short visit. The father, a quiet man, would sit down to talk with us, while his wife would busy herself with all manner of pots and pans on the stove, for if our arrival were near the dinner hour, it would have been unthinkable for us not to sit down with them and share their meal.

The children never took their eyes off us, staring at us with curiosity as if we were creatures from another world (which, in a way, I suppose we were). When we had become familiar, the children lost their shyness and showed us their paintings and carvings, which were surprising in their quality and charm, especially Mary's. Full of colour, life, and warmth, Mary's paintings recorded in loving detail the events, sights, and experiences of the world around her — the waterfall, a picnic in the apple orchard, the postman arriving by sleigh on a snowy day, or the family seated around the table on a festive occasion. When she learned of our own interest in painting, she begged us to teach her. Since we had no intention of influencing her own vision, we drew up a list of colours she could send for. It was after she started using these colours that she began doing those vivid, luminous still-life paintings of flowers and interiors for which she became so well known.

Mary was pretty in the manner of a Dresden china figurine. Dark corkscrew curls danced alongside her pale cheeks and her brown eyes shone with a feverish light, for the young girl was tubercular and would die of the disease several years later. Adding to her picturesque appearance were the dresses and hats of her own design, fashioned cunningly of silk, satin, or velvet and trimmed with bows and lace. They were striking,

most original. One outfit I remember vividly, for she wore it every Sunday that autumn. It was a sort of coat-dress made of maroon velvet, pinched in at her tiny waist, with bouffant sleeves and a high collar of black velvet and white lace. The matching wide-brimmed hat was encircled at the crown by a cloud of soft white feathers. She was a lovely picture in that outfit, her tiny pale face smiling from beneath the brim of her hat.

Their carriage passed by our house on the way to Sunday mass, and as I stared at them from our window, Mary always turned and gave me a wave of her white-gloved hand. There was ample time for a good look, because her father always slowed the horse to a walk as they approached our little house, perched at the very edge of the roadside. There must have been ten Bouchards crowded into that two-bench carriage, the younger children sitting on the knees of the older ones, the father holding the reins, with the youngest of all pinned contentedly between his arms. The mother, in poor health, was more often than not absent from these family tableaux. She, too, was to die of consumption only a few months after Mary's own death, leaving 19 year-old Celicia to bring up the other children.

Like her sister Mary, Cecilia was eventually to become well-known as a Charlevoix primitive painter, almost as well known as Mary herself, and her older brother went on to make a good living as a carver. Shortly before Mary's death, quite an interest in the art of the region had begun to develop, promoted by some wealthy Americans who owned summer homes in Pointe-au-Pic. Through their tireless and unselfish efforts, a number of exhibitions were organized, and the success of these shows did much to encourage other aspiring artists and artisans to follow the example of the Bouchard sisters. None of them, of course, managed to achieve the same degree of renown as Mary, but the exhibitions did provide a valuable outlet for creative energies in the region, until then devoted solely to the designing and making of catalognes (rag rugs) and quilts.

Handicrafts had always flourished in Charlevoix County; by virtue of necessity, and, because of geographical isolation, local artisans had retained in pure form the traditional designs and techniques of their ancestors. But conditions were rapidly changing, and, within a decade or two, a whole style of life would be eroded by modernity and all its trappings. In time, Mary's nieces and nephews would come to reject all that reminded them of the past, turning even the family's beautiful old mill to more modern purposes. Shrewdly capitalizing on the region's burgeoning tourist trade, they transformed the old mill into a factory for so-called primitive art, where their children began turning out hideous paintings and carvings, to the delight of hordes of ignorant tourists. I have not been back to visit the old mill in more than 30 years; it would be painful to see what has taken place.

SPRING & SUMMER, 1935

ON THE ROAD TO LA DÉCHARGE, but still within the confines of the village of Saint-Urbain, sat five or six tumbledown one-room shanties, where ten to fifteen Indian families lived, sharing their living quarters with countless dogs, sheep, and chickens. Whenever we passed by, masses of children would spill out of the doors and stand absolutely still, staring at us with their jet black eyes. Through the windows of the hovels, the faces of the adults peered intently, jostling each other for a better view of the strangers. These poor people were disliked and distrusted by the other villagers, who considered them thieves and vagrants, partly because they held only squatters' rights to the patches of land their huts occupied. They lived mainly by poaching salmon in the summer and hunting in the winter. Both practices were crimes, of course, and punishable by law, even though Whites and Indians alike had engaged in them regularly for centuries. Late every autumn, as freezing weather approached, each Indian family would begin laying by their winter store of meat — rabbit, deer, moose — which would be prepared in accordance with recipes handed down through the generations. Since everyone for miles around defied the game laws left and right, out of necessity, there was never any fear of being denounced to the authorities. (In fact, we once poached salmon — or, rather, accompanied those who did — and it turned out to be an exhilarating experience we would not soon forget.)

For accommodations we found a small summer kitchen, which, in this case, was completely separate from the main house across the road. It was one very large, low-ceilinged room, with at least six windows and an attic upstairs (which we never used because it was filled with old har-

nesses and discarded machinery). When we took possession, the room's sole furnishing was a small black stove, connected to the chimney by a long black pipe which snaked along just below the ceiling. The room was beautiful, simply beautiful, for the proportions were exactly right. The final storybook touch to enchant my romantic soul was a narrow brook running alongside the little house, which had trout in it. We whitewashed the place inside and out, painted the ceiling a shade of dusty rose (making the paint ourselves from a mixture of linseed oil and red earth) and the floor a pale grey. The owner of the place, the Widow Ménard, who lived opposite, was most cooperative and helpful. Her boy even built us an outhouse behind the odd-looking little hill, which cropped up abruptly at one end of a table of land that would be transformed into the most ambitious vegetable garden in the County. The outhouse was a one-holer, a most private and peaceful repair offering its visitors a truly spectacular view of the mountains.

To help us furnish the place, the widow gave us a table, and a friend from Montréal sent us a mattress and boxspring. For the rest, we made the rounds of our neighbours, and, for small sums (10 cents, 25 cents, 50 cents), bought a small half-moon table with a drawer, a dresser-armoire, and several chairs. Many years later, most of these charming pieces would figure in a scholarly book on antique French Canadian furniture. At the time, no one but ourselves seemed to be at all interested in the beauty and originality of these pieces — indeed, the farmers who owned them were delighted to be rid of them.

Our little house was right on the dirt road leading off from the village of Saint-Urbain. The road continued on into the Baie-Saint-Paul valley. Besides our own house, there were three other houses, Monsieur L'Abbé's being the last one before the wooded area which marked the limits of the village. In those woods, there was a hot spring from which clouds of steam rose, even in the wintertime. Well known to geologists,

who often came to visit the site, the spring was the source of a great deal of superstitious speculation among the local inhabitants. (Much to my regret, I can't recall a single one of the many legends which circulated about it in those days.) The hot spring was directly connected to a famous geological fault, which runs the length of the St. Lawrence Valley and has been the epicentre of some earthquake activity in my lifetime. By a curious coincidence, I was reminded of its existence many years later while attending a dinner party in Manila, which was being given by my hosts in honour of a famous American geologist, who was in the Philippines hoping to find gold. Upon hearing that I was Canadian, he asked if I by any chance knew of the tiny village of Saint-Urbain, Québec, which was renowned in geological circles for the great fault running through it. How strange it seemed to find myself in such a far-off corner of the world talking of that hot spring, which I knew only from hearsay and from the earthquake activity that had occurred during the winter of 1930.

As soon as the weather permitted, we enlisted the help of a neighbour to turn the soil and set to work on our vegetable garden. Being amateurs, we had absolutely no idea about quantities or yields. A friend in the Québec Department of Agriculture had sent us a large package of seeds containing several varieties of all the usual vegetables — beans, lettuce, carrots, beets, corn, etc. Greedy and ignorant, we planted every last one of them! More than enough for a family of ten, as it turned out. Most prolific of all were the beds of lettuce. Our neighbour Madame Laforêt came to see the garden one day when the lettuce was flourishing. Putting her hands on her hips and shaking her head ruefully, she warned us: "Ah, mes amis, vous allez chier clair, c'est pour vrai!"

We had no money to speak of, barely more than enough for luxuries like tobacco, milk, and butter, so the garden was a godsend. We kept it immaculately weeded, and the rows were plumb-line straight. On Sunday afternoons, the villagers would stroll down to admire, for none

of them bothered with gardens. A field of potatoes, a few rows of turnips, onions, and carrots were deemed enough for anyone. Big meat eaters they were, mad for pork.

That spring we collected mushrooms and morels, which grew in profusion all over the place. How those steaming bowls of morel soup — such a delicacy! — could chase away the damp chill of a Charlevoix Spring. We must have been the healthiest people in the County that summer, and possibly the happiest. It was the time of the Great Depression, yet we lived like kings. So many of our rituals of sustenance seemed to revolve around the little brook which ran alongside the house. Our drinking water, icy cold, came from there, and, at the stroke of noon each day, we'd throw a fishing line off the little bridge and never fail to hook a couple of fine trout for our lunch. On its grassy banks, I washed our dishes and scrubbed our clothes. Lovelier still, in a curve of the brook was a deep pool framed by thick bushes where, in the heat of the day, we'd bathe in the nude.

One of our earliest purchases had been an Aladdin lamp, an innovation in those days, which gave us a very good light for reading. (Now that we had our own place, we stayed at home most evenings.) During the hot summer days, we cooked our meals on the small Swedish stove, a relic from a camping trip to the Saguenay region a few years earlier, lighting the wood stove only on damp rainy days.

Our house was a most attractive little place, which so charmed our friends and visitors from Montréal and Québec City that they returned often and brought others with them. We gave large parties in that shack, which gave our friends and visitors the chance to mingle with our new friends and neighbours. There was always a fiddler, a harmonica player, or an accordionist among our local guests, and sometimes even a caller for square-dancing. As the party heated up, the dancing would be punctuated by singing. Many of our city friends, stimulated by the lively

goings-on, would soon shed their Anglo-Saxon reserve and leap to their feet to sing a few solos, too. These English songs were always listened to with attention and pleasure by our québécois neighbours, who would applaud wildly begging for more.

The exuberant gaiety of these parties, which were always impromptu affairs, was truly extraordinary, and few who attended them can have forgotten them. Many years later, I ran into one of those guests, a man now in his seventies, who reminded me of one of those veillées, exclaiming: "There must have been 40 of 50 people jammed into that room, and all of them happy as could be. And there wasn't even anything to drink!"

As our friends began to visit with greater and greater regularity, and in greater and greater numbers, we turned to our neighbours, Alphonse and Mira L'Abbé for help in lodging them. Monsieur and Madame were popular with us all. Both of them were short and round. Madame Mira always sat with her arms folded across her broad bosom, and her arms and legs, enormous loaves of flesh, were always bare and dotted with mosquito bites. Clear grey eyes peered out from deep furrows atop her fleshy cheekbones, the skin of her face smooth and soft as a baby's and shiny from scrubbing. She viewed the world with a mixture of wry tolerance and faint cynicism, and whenever she would smile, which was often, her lips would part to reveal a chalk-white expanse of store-bought teeth. As far as we could tell, Madame's mean side was reserved for her two adolescent stepdaughters. For some reason, these unfortunate young girls were the bane of her life, and she could not dissimulate it. She put me in mind of the stepmother in the classic fairy tale, only she had two young Cinderellas to do her bidding. Tiny and young as they were, they were made to work like slaves.

Her husband Alphonse was good nature itself and far too docile to thwart Madame Mira in any way. At the end of the day, when the last cow was milked, the last pail scoured, and the supper done, all he wanted to

do was settle into his rocker and smoke his pipe. Not much of a talker, he loved to listen to others, his interventions limited to the occasional "ouais, ouais, monsieur." Yet of all those I heard sing at parties in those days, none sang louder or longer than Alphonse. Some of his ballads had dozens of verses, and, at the end of each bellowing rendition, his face would be congested and alarmingly purple. He was to die a few years later of throat cancer, and I have often ruefully wondered if perhaps our too frequent demands on his voice had precipitated his death. A sweet man he was, a fatalist, a philosopher, and a prodigious worker. He and Madame Mira had had no sons, and, although Mira was energetic and strong as an ox, it was he who did all the heavy work of the farm, besides raising a pack of silver foxes and a large flock of turkeys.

Now that I think about it, whatever happened to silver foxes? In those days, they were in great demand in high fashion circles. Sometimes one would see three or four of them slung around some lady's expensive, pampered neck, biting each other's rear ends. In the late 1920s, rumours had raced around the valley that there was a fortune to be made in fox farming, so many farmers like Alphonse had built pens and cages and started breeding. Alas, no sooner had they begun when the Great Depression struck. For the fox breeders, it was a blow from which they would never recover: when prosperity eventually returned, fox fur stoles were no longer considered elegant. For several years, the breeders struggled vainly to break even, but, finally, even the die-hards had to admit defeat. Whether out of laziness or hope that the industry would one day revive, the cages were left in place for a long time thereafter, disquieting reminders of Woman's frivolity and Man's greed.

One of the more endearing characters we got to know during our stay in the area was Pamphile, an itinerant beggar who made regular stops at Alphonse and Mira's. During those days, there were many such homeless wanderers, dispossessed by the economic dislocations of the times, who

roamed the back roads of the province, stopping here and there for hand-outs. The farmers almost always treated them as honoured guests, inviting them in for a meal, a chew of tobacco, a bed for the night (or even longer if the man was old or had been on the road for days). Many of them travelled a regular circuit, stopping regularly at the houses where the welcome had been particularly warm, and some of them, like Pamphile, became familiar to us. Often on a long winter evening, we were glad of their company, for most of them had wonderful stories to tell and were only too pleased to repay our hospitality by entertaining us. They would keep up this solitary, peripatetic existence until age and failing health forced them into "retirement." What eventually happened to them we did not always learn — most simply dropped from sight, while others, the luckier ones, managed to find permanent refuge with one or another of their hosts. Though the welfare programs of today have all but eliminated those picturesque, congenial characters, the tradition of kindness and generosity toward strangers, especially the less fortunate, still prevails among many of the families of Charlevoix County.

Pamphile was one of those "gentlemen of the road" for whom retirement age had come. When we first met him, it had already been decided that he would live out his days with Alphonse and Mira. How this came about seemed a bit mysterious to us, but not to them. Without anything having been said one way or another on either side, his stopover gradually stretched into an extended visit, then into a permanent stay. Though now a member of the household "à part entière," Pamphile retained his old habits of independence. Often, he would disappear for days at a time, acting upon his return as though he had never been away. Neither Alphonse nor Mira seemed to consider this behaviour unusual, nor did they ever question him about his absences. They were genuinely fond of him, spoiling him, as did we all, with all sorts of "petites attentions," such as seeing to it that his supply of peppermints was always kept up to the

mark. He had a passion for them! His other passion was trout fishing, for which he had an unusual talent, or an unusual fund of patience, I'm not sure which. He would spend entire days along the banks of the river, returning only in time for five o'clock supper and always with his basket filled with trout, glistening among the green leaves lining the basket. No one ever knew him by any other name but Pamphile, and his origins remained obscure but whatever his early life had been, his last years, at least, were marked by contentment and serenity.

In that late autumn we decided that we would spend the coming winter in La Décharge.

AUTUMN, 1935

LATE IN SEPTEMBER, when it had become impossible to heat the little house in Saint-Urbain adequately, we looked about in the concession of La Décharge for a family who could lodge us for the winter.

Near the end of the concession, four of five miles from the village of Saint-Urbain, on the crest of a steep little hill, we discovered a small unpainted house with a mansard roof jutting out in stingy fashion over the verandah. Three short steps up from the ground and narrow as a catwalk, the verandah was only wide enough to accommodate a few chairs. Across the road was the barn, long and low, and directly opposite one could see the top of the winter vegetable cellar where the onions, potatoes, and turnips would be stored. Beyond the barn, the land dropped away steeply in great slanting fields to the roaring torrent of the Rivière du Gouffre below. The river banks, softened and shaded on both sides by trees and bushes of every description, provided dubious refuge to coteries of partridges, who lingered there every autumn at their peril. Across the river, the mountains rose abruptly, their flanks uninterrupted by fields or dwellings, bearded by a dense, unruly growth of forest.

This was where the Eloi Tremblays lived, and where we were to spend the winter. The small family of five was headed by Eloi, age 40, squat and powerfully built. His wife, Louisa, thin and disfigured by a goiter, had dark frizzy hair, the bright, darting eyes of a sparrow, and an unusually high-pitched, piercing voice. She had endured many pregnancies, but only three of the children had survived, all daughters. Alice, the eldest at 15, had the strength and coarse features of her father. Thirteen year-old Blanche, who had been paralyzed since the age of five, spent her days in a special rock-

ing chair next to the stove. Her large head balancing awkwardly on her small, misshapen body, her eyes never ceased to follow everything we were doing with intelligent, sometimes malevolent interest. The youngest, Rose, was a tiny, pretty ten year-old, the image of her mother.

It was a small farm but large enough to provide the family with subsistence. As with the Girards of La Misère, the family's needs were quite elementary and were met, for the most part, by the fruits of their own efforts. There was a horse and an ox for ploughing, two or three cows for milk and cream, sheep for wool, and an assortment of chickens and pigs. Though the farm was small in terms of its scale of operations, it was actually quite large in acreage (which was typical in Charlevoix), with extensive wooded areas. The timber and pulpwood provided extra income in the spring, and Eloi would spend much of the winter months cutting, hauling, cording the logs.

Although there were only two houses further on, the road continued up through cultivated fields and pasture lands along the sloping edge of the mountain, meandering for several miles all the way to the last concession of St.-Hilarion, offering travellers a spectacular view of the dense forests below with occasional glimpses of the river through the trees. In bad weather, when skies were heavy and low, this view could be the gloomiest sight in the world, so empty was it of any sign of human activity. Although it was often said that black pearls had once been found in the river, down where it coursed through the thickest part of the forest, we met few who had ever ventured down there to verify the legend. Something alien and foreboding about the area discouraged exploration.

Eloi had built his house himself with the help of his brother and neighbours. As was the custom, his older brother Alzarius had inherited the paternal homestead, which was down the road at the curve by the bridge. There, a hive of children, chickens, cats, and dogs would pour continually in and out of the house, in marked contrast to the relative serenity which reigned in Eloi's household.

Eloi's wife, Louisa, who excelled in the domestic arts, was fanatically devoted to order and calm. She worked from morning to night; never once in all the time I knew her did I ever see her simply sit and daydream. Every moment of the day was allocated to some duty or chore, which was reflected in the immaculate state of the premises. The kitchen was bright and gay, very much resembling the Girards' — the same floor of vivid orange, the striped catalogne runners, the muslin curtains, the plants on the recessed window ledges. Off the kitchen, there were two bedrooms, one shared by Alice and Rose, the other by Blanche and her parents, Blanche sleeping in a child's cot.

As at the Girards' we were given a pine-finished room just off the attic. The attic itself was jammed — in perfect order, of course — with boxes of all sizes and descriptions. As I found out later, Madame Louisa was a squirrel. The clothing I would give her (always in good condition) was put away in the attic and never seen again.

One corner of the attic, next to a window, was reserved for the loom, which was set up for weaving with the coming of the first chilly, rainy days of autumn. As soon as the seasonal outdoor work was completed, either Madame Louisa or Alice would retreat upstairs to spend long afternoons at the loom. After a time, we got used to the rhythmic thudding noises of the shuttle and the monotonous keening of their singing. When silence fell, it was either time to change the weave or time to quit for the day, as the work could not go on after dark.

By winter's end, there were bolts of linen and homespun, runners and bedspreads of catalogne, and woolen blankets, the most beautiful of all. Everything was splendid, just splendid. All the colours were home-dyed, and how vivid they were! All the designs were a blend of tradition and individual inventiveness; that is, the motifs used would follow the traditional patterns, but the choice of colours and their arrangement would be of Louisa's own design. Louisa was also one of the very last

weavers of the "ceinture flèchée," a technique in which the weaver uses her own fingers instead of a loom, tacking a hundred or so strands of wool to the back of a chair and braiding them by hand. Although it sounds simple, the technique is actually very intricate and demands enormous patience.

Not satisfied with her full day of work, Louisa would spend long evenings — and they were long, for we supped at five o'clock — knitting or mending. I'll never forget the socks she made for Eloi! Made of coarse natural-coloured wool, they appeared an inch thick. When he came in for supper, he'd fall heavily into a rocking chair next to the stove, remove his high soft mukluks, pull off two pairs of these socks, hang them up neatly on a cord behind the stove, then pad around for the rest of the evening with the pair he had left on his feet! When fully dressed for cold weather chores outside, he looked every bit like the trunk of an old tree, a bulky, bulging cylinder of dun-coloured wool and cloth. I frequently saw him in his cream-coloured homespun underwear, which covered him entirely except for his hands, neck, and feet. Every Saturday afternoon, in the privacy of their bedroom, Eloi and Louisa would take their weekly sponge baths, taking turns carrying pails of hot water back and forth. His ablution finished, Eloi would then don a clean set of underwear, which would only be removed the following Saturday, for it served him as sleeping apparel as well. In summer as in winter, this warm underwear was considered essential for preventing colds and fevers. Even today, in the village where I now live, it is not uncommon to see long-johns hanging from a neighbour's clothesline on a Monday morning, silent, slapping symbols of the older generation's tenacious adherence to custom.

Saturday morning was always a busy time in the Tremblay household. After scouring the house, the two girls would get down on hands and knees to scrub the kitchen floor with a strong solution of lye. Meanwhile, Madame would rush about baking and cooking, getting preparations for the Sunday meal under way, in case it would be her turn

to go to Mass. (Blanche, the paralyzed daughter, could never be left alone.)

By three o'clock, all the bustling about would come to an end, and everyone would be sitting or rocking, gleaming with cleanliness and conscious of wearing their Sunday clothes under their spotless aprons. Since our arrival, Louisa had begun serving Saturday supper a little earlier, because the people of the concession had gotten into the habit of spending their Saturday evenings at the Tremblays'. (We were apparently something of an attraction.) Whole families, some from as far as three miles away, would begin arriving in wagons or on foot. Sometimes they would show up at the door even before we had finished eating, and both Madame and Eloi would rise from the table to greet them. While Madame helped the women and children remove their wraps, Eloi would go with the men to tether the horses and cover them with blankets.

During a typical veillée at the Tremblays', as many as forty people would jam themselves into the kitchen. The older ones were always given the rocking chairs; the straight chairs were divided among the younger married couples. The young men and women who were courting would squeeze themselves onto the two long benches, and the children would find whatever space they could on the staircase, or the floor, or lounging against the knees of their parents. The babies would spend the evening sleeping among the coats, shawls, and scarves heaped on the beds. So relaxed and informal was the atmosphere at these parties — "à la bonne franquette" — that no refreshments of any kind were ever served; not so much as a biscuit was passed! Whenever guests were thirsty, they drank from a pail of fresh spring water that had been hung from the ceiling, climbing over people as best they could to get to it. How thirsty these people always seemed to be. All evening long there would be constant traffic trooping to and from that pail, so that Eloi would have to make several trips to the brook behind the house to refill the pail.

The veillées at the Tremblays' were much the same as those we had

attended at the Girards', only louder and more rambunctious. Everyone who attended had known everyone else since childhood. No one stood on ceremony; everyone was remarkably free and uninhibited in their behaviour. Special enthusiasm was reserved for the Spider Game, which was played and watched with the same passion one sees at a hockey match today. To play the game, all the furniture would be shoved back against the walls, and everyone would stand back to create a space in the middle of the floor. Then, two men, usually the biggest or strongest, would volunteer to start the proceedings. One of them would lie flat on the floor, the other man straddling him, whereupon the man underneath would suddenly seize the other with a pincer-like grip of his arms and legs and try to turn him over. It would then be the top man's turn to try to shake free. As they grappled desperately, careening rapidly and awkwardly for several minutes across the cramped floorspace, the two men did indeed resemble an enormous spider. The screaming and shouting of the other guests would goad the players to extraordinary efforts, the effects of which were so absurdly comical that I found myself alternating between bouts of uncontrollable laughter and fear that their boisterous antics would bring the house down.

Of course, the Spider Game was not the only form of entertainment to be had at Eloi's. Though there was not enough space for square dancing, we always managed to find enough room for some of us to do our solo "jigs." In the concession of La Décharge, there were several "violonneux" and any number of harmonica players, all of whom played surprisingly well. None of them had ever had a formal lesson; usually, they had inherited their particular instrument from another member of the family and simply noodled about on it till the techniques and the musical repertoire were mastered. All evening long, they would regale us with rollicking, toe-tapping tunes, almost never repeating themselves except to honour special requests. Needless to say, they were much in demand

for local weddings — oh, those weddings! — where they would take turns providing non-stop entertainment for three days running. Usually paid a flat fee for their services, they earned every penny of it, for they were on call at any time of the day or night throughout the festivities.

At the Tremblays' veillées, there was singing, too, but the songs, as was the custom, were delivered a cappella. The singer would always stand up, eyes shut tight in fervent concentration and hanging on for dear life to his chair, and sing as loudly as possible. A good strong voice was much admired. No matter how awful the singing voice or how dull the song, the singer was always listened to in polite, rapt silence and applauded with a hearty chorus of "marci, marci" when finished. It puzzled me that none of those asked to sing ever refused or showed the slightest sign of embarrassment or timidity about their skills. Though my own shyness in the face of their tolerant, unself-conscious naturalness shamed me, it was a long time before I would feel uninhibited enough to offer a contribution of my own to the entertainment.

The people of Charlevoix in those days were natural in all their ways. Though I admired their spontaneity and lack of artifice, their frankness often made me uneasy, especially when it came to bodily functions. In time I got over this, but it was amusing to see the effects their candor could produce on some of our unsuspecting visitors from the city. During one such visit, Madame Louisa overheard my visiting friend (a rather strait-laced lady) ask me for directions to the outhouse. Breaking into our whispered consultation, Madame said, in that high, piercing voice of hers, "Gênez-vous pas, madame. Si vous voulez pisser, il y a un pot de chambre sous le lit." Madame Louisa was a gentle, sensitive creature, incapable of vulgarity; however, there is no doubt in my mind that, had she believed that needs of a more "important" nature were involved, she would have felt no compunction about saying, "Si vous voulez chier, madame, vous trouverez l'endroit dans la grange."

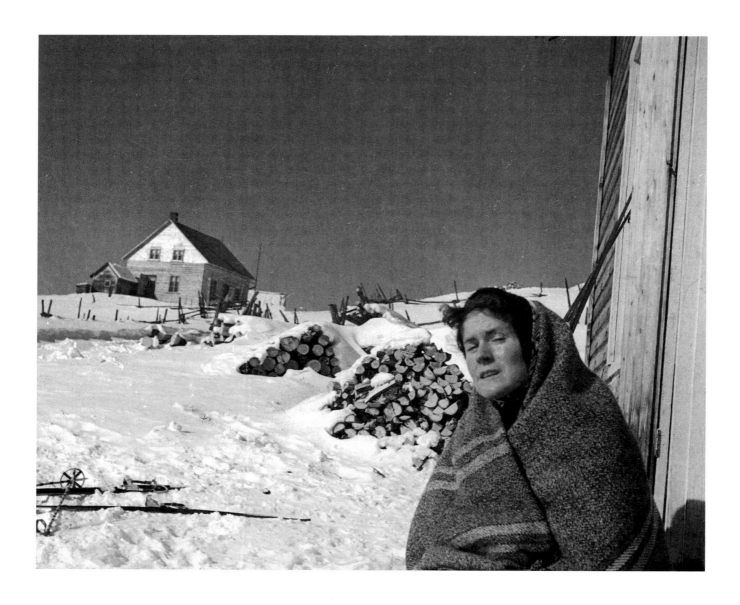

Jean Palardy, *Jori Smith: Chez Eloi Tremblay*, March 1935, b/w photograph (48 x 60 cm). "I was sitting there one morning enjoying the March sun when Jean arrived from sketching down the road. He said, 'Say, that's a great composition for a photograph, stay like that and I'll get the camera.' So he took off his skis, got the camera and here it is."

WINTER, 1935-36

WINTER WAS ONE LONG SERIES of veillées, often three times a week, in one or another of the houses along the concession. Even in the unkindest weather, as soon as the supper dishes were cleared away, we would hurry to the party, trudging through the snow on foot or harnessing the horses for destinations further away. Vividly I recall those late-night sleigh rides home, the cold clear beauty of those moonlit nights, the swishing and crunching of steel runners along the icy roads, the silence a delight after the uproarious din of the veillée.

On evenings when we were not visiting elsewhere, the family assembled in the kitchen, and we read aloud from *Robinson Crusoe*. This gave them great pleasure, for they would sigh with regret when the book was closed for the night. Most disappointed of all was the crippled daughter Blanche. Because of her paralysis, speaking or making any sounds at all required such effort that Blanche had learned to express herself eloquently with her eyes alone, using a language which the others had learned to interpret. To attract our attention, she would bang the flat of her hand on the arm of her chair until one of us would look her way. Usually it was her mother, who always responded with great tenderness and cheerfulness. "Ah, la petite Blanche, qu'est-ce que tu veux? Regardez-la donc, elle veut que Monsieur commence à lire l'histoire. Attend, ma petite, qu'on serre la vaisselle et que Monsieur se repose un peu. Ce sera pas long à c't'heure." What a marvelous story, *Robinson Crusoe*. It cast a magic spell in that isolated wintry corner.

AFTER WE RETIRED FOR THE NIGHT, the family knelt down for prayers, which

Madame Louise intoned aloud accompanied by the responses of the others. Then Eloi banked the stove and added a green log, which could be counted on to leave enough red embers for a quick revival the next morning.

The first one up, at five o'clock, Eloi would stoke the fire and sit next to the stove, waiting for just the right moment to fill it up with dry wood. For ten or fifteen minutes, he'd just sit there, waiting patiently for the kitchen to warm up a bit. Though it would still be dark at this hour, no lamps were lit. Then Eloi would pull on yesterday's socks, all warmed up and cozy, pull on his beautiful long deerskin moccasins and his heavy homespun shirt of exquisite colours, now faded from countless washings, over which he would draw a vest and pants of thick black cloth. The pants would then be tucked carefully into the tops of his loosely-laced moccasins. Covering all these undergarments was a bulky Mackinaw jacket, which he could button up and belt, as he did, with studied precision. (Eloi was, like his wife, an orderly person, who did everything in a certain way and always in that way.) Finally, he'd take his wool cap off the hook by the door, jam it down, and head out to feed the livestock. By then, Madame would be up and about, busily preparing Blanche for her long day next to the stove. When Eloi returned for breakfast, they would both carry her to the chair and get her settled. The routine never varied, or rarely. So predictable were they that we grew to know, at any hour of the day, what they would be doing.

Two or three times during the closing weeks of winter, Eloi would pile logs onto his sleigh and take them to St.-Agnès to be squared and planed for the repairs he planned to do on the house or the barn that spring. He preferred that sawmill to the one at Saint-Urbain because the former was owned and operated by one of his wife's cousins, who always gave him special rates and, better still, treated his visits as an occasion to celebrate. Eloi unvariably returned home from these trips dead drunk, so intoxicated he would often have serious accidents en route. Louisa

dreaded these expeditions. Each time before his departure, she would entreat him to resist temptation, and all during his absence she would pray for his safe return. Her divine intercessions may have done some good, for Eloi always managed to make it home in one piece.

Once Eloi had arrived home, however, usually long after midnight, Madame's troubles were far from over, for he would invariably suffer a violently purgative attack of remorse for his debauchery. What triggered these episodes is hard to say: perhaps the heat of the room, perhaps the glare from Louisa's eyes, as she stood above his hunched-over figure like an avenging angel. Whatever it was, the very moment he crossed the threshold, before he could even remove his coat, he would be seized by a prodigious bout of retching. Vomit would pour in torrents from his mouth, splashing his clothes and cascading to the floor, whereupon he would pitch forward into the viscous puddle with a heart-rending groan of pain and shame.

There was no need for us to come down from the attic to investigate the cause of all the ruckus, for we could count on Madame to tell all the following morning. "Si je vous disais, Monsieur, Madame, comment il a été malade, vous ne m'en croiriez pas! Tiens, il vomissait tellement qu'il y avait une rivière à terre, et il est tombé là-dedans, en plein là-dedans. Et ça sentait mauvais; ça sentait la marde, oui, je n'exagère pas, ça sentait la marde. J'étais ben découragée. Et lui, presque sans connaissance, qui hurlait comme un veau. Je n'aurais jamais été capable de le tirer de là tout seule, mais avec Alice et Rose, on est venu au bout de nos peines, mais pas au bout de nos misères.... Après qu'Eloi ait été déshabillé, lavé et mis au lit, on a passé au moins deux heures à laver la cuisine. Il y avait du vomi partout, il va sans dire. Et ses vêtements, mondou, mondou, une écoeuranterie, je vous le dis." She paused and pointed to her wayward spouse, now seated at the table enjoying his breakfast with the rest of us. "Et regardez-le donc, Monsieur, Madame. Il n'a même pas l'air d'avoir

honte. Il est prêt à recommencer, je gage."

Indeed, there he was, apparently none the worse for wear and wolfing down his eggs as if last night's misadventures had never occurred. He appeared in no way embarrassed to be talked about in this way; in fact, he even seemed proud of himself. These seasonal binges had become a part of his life, a necessary ritual, a way of letting himself go, their saving grace being that they were infrequent. Between binges, Eloi never drank, never took even the smallest glass of spirits. To her credit, Madame Louisa realized this and, despite her harangues, really did understand and accept the importance of these occasional lapses. After the dressing-down, she would not refer to the incident again — that is, until the next "lendemain après la veille."

As for Blanche, she thoroughly enjoyed these scenes. In her chair by the stove, her tiny body would heave with the laughter she could not express, much amused by Madame Louisa's attempts to humiliate her father. Eloi did not much appreciate her laughter and would pretend to ignore her. Now and then, he would glance at Blanche somewhat apprehensively, as though he feared this strange little creature could somehow read more of his secret soul than he cared to reveal. His unease was understandable, for Blanche often had this effect on people. Her eyes were so extraordinarily bright and penetrating in their wisdom — no, wisdom is not too strong a word — that I, too, often sensed that she had access to the inner vaults of my mind. Perhaps because of this, the entire family deferred to her and treated her with great respect. As incongruous as it may seem, they often solicited her opinion: "Qu'est-ce que tu penses de ceci, Blanche? Ou ça, crois-tu que ce serait mieux?" The wonder of it was, of course, that they could understand her at all, having only eye movements and grunts to interpret. But interpret her, they did. And she never gave any sign that the meanings they attached to her communications were wrong.

UP ON THE HILL, BEYOND our line of sight, was the last house on the concession, an unpainted hovel, its ramshackle appearance suggesting that no attention had been paid to it since its construction. Shingles had fallen away and had never been replaced, loose planks never nailed back, and the verandah sagged at will.

This was the house of Xavier Fortin, his wife, and fifteen children. Their tiny plot of land was the poorest in the region, precious little but rocks and tangles of scrub. How Xavier managed to feed and clothe so many dependents was the subject of much speculation among his neighbours. One could do nothing to help this family, for Xavier rebuffed any and all charitable offers with disdain.

A tall skeleton of a man, Xavier was a living scarecrow, especially when one saw him at work in the fields, his clothes flapping about his bony frame. His four older sons, who shared in the more strenuous chores of the ploughing and logging, promised to rival their father in height and gauntness. The Fortins were a clan of hermits, who carried standoffishness to the point of refusing to exchange all but the barest of civil greetings with their neighbours. Friendly intercourse was discouraged even further by the presence of a huge, ill-tempered mongrel, who would be released into the yard whenever anyone was foolhardy enough to approach the house. A member of the family was always posted at one of the front windows, no doubt to ensure that this operation was timed with exactness.

One day, curiosity overcoming our discretion, we went to visit them. After subduing the dog, we made our way up the path to the front door, aware we were being observed with alarm from within. We waited on the doorstep, but the door remained shut. When, at long last, the door opened, there stood Xavier, motionless, silent and forbidding. Pretending not to notice his hostility, we pushed past him and moved toward the stove, where his wife stood timidly smiling, as though to reassure us that

she, at least, was glad of our visit. Averting her husband's glance, Madame Fortin offered us chairs and motioned for the children to behave themselves. We began the conversational ritual about the weather and the season, glancing curiously now and again at our surroundings, not wishing to offend. We were successful in this, for Xavier relaxed his guard a trifle. Seating himself next to the spittoon, he took out his tobacco pouch and offered it to us.

Though the kitchen was large, it seemed small because of all the children. As we talked with hundreds of eyes upon us, I became conscious of how peculiar we must have appeared to them. Dressed as I was in a ski suit, I must have seemed very odd indeed to the children, who had surely never seen a woman dressed in pants before.

Except for the occasional grudging "oui" or "non" from Xavier, we did all the talking, conversing in a tone we hoped would inspire their confidence. To us, it was sad that we should not be as friendly with these neighbours as with all the others in the concession. Beyond friendship, we were hoping to offer them our help as well, perhaps some medicine, some advice, or some clothing for the children (who were literally in rags). It was our feeling that, as strangers, we might have a better chance than the local people of penetrating their stubborn pride and resistance to charity.

After some time, the family appeared to feel more at ease in our company. Now and then, some of the younger ones would stifle a giggle at some ludicrous remark I had slyly directed to them, and even Xavier, though still suspicious and reserved, seemed to loosen up a bit. When Madame Fortin indicated their sick child sitting near the stove and asked our advice, Xavier encouraged us to examine her.

Pale and droopy, the little girl was rolling the edge of her dress between gaunt fingers. We had only to open her mouth to know she had diphtheria. To our suggestion that a doctor be called right away, Xavier

retorted they had never in their lives sent for a doctor and weren't about to start now. "Jamais, et mes enfants ont toujours survécu ces maladies-là!" Beyond his anger, Xavier appeared surprised, even disappointed, as though he had just begun to like us, only to discover that we were no more than patronizing meddlers like the rest. And strangers, to boot! Putting on our jackets, we bade them goodbye and left.

With the sound of the banging door still in our ears, we skied straight down the mountain to the Barrette's — one of the only families for miles around who had a telephone — to tell the doctor in Baie-Saint-Paul that he had a case of diphtheria to attend to in La Décharge. In those days, there was only one doctor to serve a vast territory, and he was too old for the job, overworked and underpaid. Needless to say, he was anything but thrilled with our news. "Et qui va me payer, monsieur? C'est un très long voyage. Ca va me prendre au moins trois heures, aller-retour, et les gens de là-bas n'ont pas le sou. C'est tout de même trop à me demander!" he sputtered indignantly.

From his meetings with us on several prior occasions during our winter stay in Baie-Saint-Paul, he knew very well how we would interpret his refusal to visit a child suffering from an infectious disease. Calming down, he asked warily, "Vous êtes bien sûr que c'est la diphtérie dont elle souffre, monsieur, et non un simple angine?"

In the face of our insistence that we were not mistaken, he relented. "Bon, bon, j'irai cet après-midi. Il faudrait aussi que j'emporte une pancarte pour la maison et que je fasse fermer l'école du rang." He sighed wearily and hung up the phone.

When we got back home, very late for lunch, the story we had to tell evoked eager curiosity and glee. Eloi's family was astonished enough that we had stopped at the Fortin house, but the fact that we had even entered the house and visited with these strange, reclusive neighbours really surprised them. They asked us questions about everything, anx-

ious for details. We were surprised that they showed less concern about the sick child than about the conditions inside the house: was it clean, were there catalognes on the floor, did they ask us to stay for dinner, what was cooking on the stove...? They seemed indifferent to our worry about a diphtheria epidemic sweeping the concession, even bored by it. In fact, they disapproved altogether of our interference. To them, the idea of sending for a doctor was outlandish, unheard of in this area, and Xavier was justified in reacting as he had. The disapproval and empathy showed candidly in their faces as they silently mulled over the predicament we had put Xavier in with our well-intentioned interference. How on earth would Xavier and his family cope with a visit from the doctor, a stranger come all the way from Baie-St.- Paul? And where would the man ever find the huge sum — 15 dollars, at least — to pay the doctor for his unwanted, but now unavoidable, services?

Madame Louisa, even more than the others, had no use for doctors. Not under any circumstances. In all Louisa's pregnancies, it was always the local midwife, Madame Barrette, who had done what needed to be done when the time came. Of course, many of the babies had died, but surely no doctor could have done better, for it was the will of God. Even in the more difficult cases, she believed in self-sufficiency and the hand of God. For example, after Blanche's paralysis, Madame Louisa had had no qualms whatsoever about performing an operation herself so that the child could make some kind of sound.

"Et puis, comment avez-vous fait?" I had asked.

"C'était très simple," she had shrugged, "j'ai pris les ciseaux, et j'ai coupé la corde qui semblait empêcher la langue de bouger."

For the remainder of the afternoon, Louisa was distracted and agitated, as if waiting. Blanche, too, had taken up a vigil of sorts, peering intently out the window. From her station beside the stove, she had a clear view of the twisting road, all the way to where it disappeared

behind her uncle Alzarius' house. Just before sunset, when the gathering darkness would soon make any further watching useless, Blanche erupted into sounds. At this signal, Madame and the two older girls stationed themselves by the front windows, shielding themselves partially behind the curtains. Suddenly, the doctor's horse and sleigh came into view. At his approach, the women began a running commentary, lowering their voices as though afraid he might overhear them.

"Son cheval est ben beau. Il prend bien la côte."

"Je peux ben croire, il l'a eu d'Eusèbe Fortin, qui l'a eu de Victor su Albert. Victor n'a jamais dit à ton père combien il l'a payé, mais avezvous remarqué le nouveau harnais qu'il avait à son cheval lorsqu'il a passé jeudi dernier...?" Her voice trailed off in a hiss.

As the sleigh now passed directly in front of the house, every detail of the conveyance and its passenger was being studied in total silence by the women of the house. Only the doctor's nose in profile could be seen poking out from under his black lamb hat, the rest of him completely enshrouded by the buffalo robe.

The following day, Rose came back from school early in the morning with the news. A notice had been tacked onto the school door advising that, due to an epidemic, the school would remain closed until further notice. Later that same day, we learned that the doctor had also nailed a quarantine notice to Xavier's porch railing, but that it had been removed as soon as the doctor's sleigh had disappeared down the hill. The little Fortin girl died a week later. Fortunately, although cases of diphtheria did eventually develop among several other families on the concession, no other deaths were reported. At the time, I wondered by what miracle the concession had gotten off so lightly. Perhaps the local inhabitants, being so often exposed to the microbes, had developed a resistance to them. I really don't know. Whatever the reason, the turn of events served to confirm Madame's belief that doctors were of no use in time of illness: after all, she

argued, the child had died after the doctor's visit, hadn't she? So there.

The attitude of skepticism bordering on contempt was not reserved for doctors alone. The inhabitants of the region had much the same regard for dentists. From a very early age onward, their teeth would rot and fall out one by one. When a girl was about to marry, her few remaining teeth would routinely be pulled out, and, as a wedding present, she would be given a set of false teeth. If, by some rare stroke of fortune, the future bride's teeth were still healthy, they would be removed anyway, so great was the prestige of store-bought teeth. How surprised these people always were to learn that we, then in our twenties, still had all our teeth, though adorned here and there with fillings of silver and gold. The idea of repairing one's original teeth with tiny plugs of precious metals struck them as particularly wasteful and irrational: "Mondou, mondou, vous parlez d'une extravagance pareille!" Alas, even today [1970], this state of dental hygiene still prevails in the region. Instead of visiting the dentist in Baie-Saint-Paul, many people simply yank out the offending tooth. In fact, it is not uncommon to see a child of fourteen already wearing false teeth, and quite unself-conscious about it. Why this should still be the case, I have no idea, for it is surely no longer a question of money, as my neighbours are prosperous. Apparently, store-bought teeth are still a powerful talisman of prestige.

I remember a next-door neighbour who had had all her teeth extracted while still a young girl. When I knew her she was earning her living as a schoolteacher and could not afford two denture plates, so she decided to have only an upper one made. However, by the time she had saved enough money to buy herself the lower plate, she found that she no longer wanted it. As the years went by, her gums receded and her chin jutted forward to such an extent that she would have passed for a witch had it not been for her remarkable eyes.

One thing that always struck me as odd about their teeth was that the

men seemed to preserve theirs much longer than did the women, or at least some of them did. The men seemed less inclined toward the vanities of false teeth, exposing with no apparent self-consciousness their ravaged gumlines, which always put me in mind of tumble-down picket fences, their crooked teeth widely spaced and yellowed by interminable pipe smoking. In those days, of course, no one ever cleaned their teeth, be they original or not.

Actually, in those days the people of the region weren't particularly fastidious about washing, in general; a daily perfunctory scrubbing of the hands and face had to suffice until the more thorough ceremony of Saturday baths. In most cases, their habits in this regard had little to do with lack of pride and everything to do with the complicated logistics of daily living. Take the Tremblays, for example. Since water could not be piped in from the brook behind Eloi's house during the freezing winter weather, keeping enough water on hand for everyone's daily requirements was no easy task. We were, therefore, careful not to waste a drop. Often, I'd see Madame finish washing her hands and motion to the girls to come use the same basin of water. Indigent though we were, as city dwellers, this eternal vigilance about waste was new to us. More than that, it impressed us, even touched us. All of life's necessities, which we had taken so for granted in the city, were severely limited here. As a result, they were carefully husbanded, as if sacred, and managed with surprising creativity. Any constraints or inconveniences we may have felt initially soon melted away as we grew to understand and share the local attitude of frugality. Given our own financial straits, we found much of value to be learned on that score. (At the Tremblays', as at the Girards', room and board for the two of us cost $4 per week, which was everything we had at the time and several years to come.)

SPRING & SUMMER, 1936

IN THE SPRING OF 1933, we began to think of moving back to our little summer kitchen in Saint-Urbain, waiting only for the return of weather warm enough to permit us to make the trip in Eloi's open carriage. So, one bright, lovely day in late April, Eloi helped us pack up our things and took us down the muddy, slushy road to the village. Although snow still lay in the fields, the Spring sunshine was uncovering patches of brown earth more and more quickly each day. By now, the snow had slid off the roofs of most of the houses and barns. As we rumbled along, we couldn't help remarking that it all looked exactly like a painting by A.Y. Jackson, and not until then had I appreciated how perfectly he had captured the colour and atmosphere of Charlevoix County in Spring.

All the way to the village, a good five or six miles, our friends and acquaintances waved to us from their windows. Men were bustling about their houses and yards, repairing the damage winter had done, while the children splashed about in the pools of muddy water. All stopped for a moment to salute us as we passed. We had spent a happy winter with the Tremblays, and we were leaving with some regret. This was not really goodbye, though, as we would return to visit them often.

Once settled, we resumed with relish our carefree, bohemian life in Saint-Urbain, once again living most satisfactorily off the produce of our garden and the trout stream. More and more of our city friends began visiting us, some of them lodging with Alphonse and Mira L'Abbé, who were delighted to have summer boarders. Those of our friends who were fortunate enough to own cars usually put up in a hotel in Baie-Saint-Paul. All that summer, there seemed to be an unending stream of people

coming and going. The weekends were the most crowded times of all, for the Saturday veillées had become a regular event, and one which our city friends could not bear to miss.

When Marius Barbeau, the renowned anthropologist with the Museum of Man, came from Ottawa to spend a working holiday in the Charlevoix region that summer, we abandoned everything to travel about the countryside with him. Although billeted at the little hotel in Baie-Saint-Paul, he'd drive up to Saint-Urbain early every morning, his panel truck loaded with all his recording equipment. Picnic basket at the ready, we'd pile into the wide front seat and off we'd go for the day, returning only late in the afternoon. Hour after hour, we'd go bumping along the corrugated concession roads, taking in all the sights around us, in some concessions stopping at every house. Marius was the worst driver of any man ever born, hardly knowing one gear from another, but who cared? We were happy. Every day was an adventure.

Marius' objective that summer was to record the songs and folklore of Charlevoix, and he was hoping that these leisurely wide-ranging jaunts of ours would uncover some as yet undiscovered songs. Whenever he heard a new version of a familiar air, he would quickly jot it down in his notebook. But when the song was completely new to him, he would capture it on his recording machine, much to the delight and wonderment of the singers, most of whom had never seen or heard of such a thing. There was one wonderful little old lady who positively enchanted us with her singing, so much so that Marius insisted we return a second time to visit her, this time bearing a gift of the peppermints she adored. All in all, Marius was quite pleased with what he was able to collect that summer.

He was a delightful companion. Everything interested him. Yet, despite his devotion to the task he had set for himself that summer, he was always ready to relax and enjoy the moment and was surprisingly young and gay for his age. (In retrospect, I feel silly saying such a thing, as he was

surely no older than his early fifties. But, from our vantage point of twenty years younger, he seemed remarkably youthful for his "advanced age.")

When we were hungry, we'd stop and eat our sandwiches in some pleasant spot. After lunch, we'd wander about picking berries or lounge under a tree, talking the whole time. Marius taught us so much, drawing from a boundless fund of knowledge and experience, and he communicated to us his own enthusiasm for the folklore of the region. Though we ourselves had been deeply interested in the people and the local culture since the beginning of our sojourn, with this remarkable folklorist we found our interest broadening and deepening. His obvious affection for us and his enjoyment of our company touched us both very much, and I think he, too, was pleased by our obvious admiration for him.

Apart from song and story collecting, Marius was also interested in old Québec furniture. We took him to many houses where we had seen interesting pieces, and some of these he bought for the museum. The hooked rugs in particular fascinated him, for he found their designs reminiscent of primitive Nordic motifs he had seen. In his wide-ranging curiosity, he had eyes and ears for every object, every nuance of speech and language. Not even recipes for regional dishes escaped his avid attention. One day I served him a plate of pickled trout which I had prepared from a recipe given to me by Madame Ménard, our landlady. Pronouncing it delicious, a gourmet delight, Marius promptly flipped open his notebook and jotted down the recipe. He came to be equally fond of our home-made beer. I can no longer remember how we brewed it, but I do remember leaving one batch of it too long under the trap door, which unleashed a series of explosions one day when the three of us were quietly eating lunch. Just like pistol shots, they were — bang! bang! bang! We found the cellar awash in beer and strewn with bottles and shards of glass. Marius laughed till he cried. That was the last time we brewed our own beer, although we did once try making wine with rowanberries.

What a disappointment that was! It tasted like mouthwash. Needless to say, that was one recipe that didn't make it into Marius' little notebook.

Before Marius returned to Ottawa, we drove together to La Décharge in our usual leisurely, stop-and-go fashion, intending to pay a visit to the Tremblays. However, just before we reached Eloi's place, we were distracted by the sight of a group of men lounging about in front of Elie Lavoie's house. They were all dressed up in Sunday-best dark suits and black hats, and, as we came near, sounds of an accordion floated out from the Lavoie house. A wedding. As we drew up, Elie himself came out and invited us in. I remember being thankful that I had chosen to wear my pink cotton mesh dress that day, as my usual attire, blue jeans, would hardly have been de rigueur for such an occasion.

All noise and movement ceased abruptly as we stepped across the threshold. The room, very large, was full of people, the older ones sitting in chairs lining the walls, the younger ones shifting from one foot to another in the middle of the floor, politely waiting for us to be settled before resuming their dancing. Someone was dispatched upstairs to inform the bride and groom of our arrival. As they slowly and shyly appeared at the head of the stairs, everyone looked up, laughing and shouting ribald remarks at them as they made their way down the stairs. Though the young couple grinned awkwardly at us, they did not appear unduly embarrassed by the circumstances. Such teasing was the custom, and, since they had already been married 24 hours, they were surely inured to it by the time we arrived. In fact, we were the ones who felt embarrassed. Out of politeness, they sat with us for a while. But, as soon as a reel started up again, they excused themselves and, with dignity and naturalness, made their way back up to the bedroom, oblivious to the volleys of coarse humour that accompanied them.

The accordionist and the violinist, both hired for the three-day marathon of celebration, took turns providing the music. The square-

dance caller was a professional — from St.-Hilarion, I believe — with the most wonderful loud, ringing voice. The noise in that room was deafening, but his calls and commands could be heard clearly by all of us. I say "us" because we, too, were expected to join in the festivities, which we did with great gusto. When invited to dance by Elie's father, I jumped to my feet with joy. By that time, I had learned to square dance quite well, provided I had a good partner, and old Monsieur Lavoie was both sure of foot and full of pep. What fun I had that afternoon. Truly, there is no form of social dancing quite as exhilarating as square dancing; one never seems to tire. But as I whirled past the two downstairs bedroom doors, I realized that the long drawn-out merriment had taken its toll on some of the guests, at least for a while. Sleeping people could be seen sprawled over beds, chairs, floors, just about any flat surface. Once rested, though, they'd spring to life and start all over again.

The huge kitchen table, pushed under the stairs, was by then an untidy mess of food and dirty dishes. As was the custom, the guests had all brought contributions of food from which everyone helped themselves. The tall tin teapot was steeping, kept hot on the stove and replenished at intervals by Elie's wife, Rose. In her late twenties, Rose was as round as a pumpkin, very fat indeed. Her hair was black as jet with a bluish sheen, her eyes like onyx. At least three-quarters Indian, she reminded me of the stunning squaws I had admired at the Pointe Bleue settlement several years before. Although we had tried to be as friendly with the Lavoies as with the other families in the concession, Rose had never relaxed her guard with me. That day of the wedding, several times I noticed her staring at me with moody suspicion — suspicious of what I could not imagine. Exhausted by all her duties as hostess, she had fallen sound asleep in her chair by the time we left.

We never did get to see the Tremblays that day. They had not been invited to the Lavoie wedding, apparently the result of some ancient trib-

al enmity. In those days, there was quite a bit of bad feeling among families on that concession.

And what was Marius doing while we were stepping high that afternoon? Research, as usual. Not one single object or piece of furniture in the place escaped his scrutiny. He made his way about the room, jostling and being jostled by the whirling dancers, examining the chromos on the walls, bending to look at the runners on a chair, sometimes even asking, in his gentle and quiet way, one or another of the guests to get up a moment so that he could have a look at the curve of the chair seat. Neither the noise nor the activity around him made a dent in his concentration.

As fascinated as he was with man and his works, man as an individual didn't seem to interest Marius, at least not as a field of scientific study. Unless, of course, the particular individual could share his passion or contribute to it in some direct way. Sometimes during the days we spent endlessly drawing out the storytellers or listening to the singers, there were moments when these people would suddenly interrupt their story or their song to embark on some tangent of personal interest to them. Whenever such digression would occur, a look of patient boredom would come over Marius' face, as if he were thinking "Get on with it, get on with it." Personally, I often longed for these digression to go on forever, so colourful and amusing were they. But, no, for Marius, it was strictly business; no personalities, s'il-vous-plaît. Whenever one of our hosts became aware of Marius' impatience or flagging interest, they would react with surprise and discomfiture. To their minds, it was inconceivable that this kind, erudite stranger, who asked so many questions about them, would not be interested in whatever sidetrack their narrative might take. They seemed puzzled and a bit regretful that the pleasant remembrances Marius' questions had evoked would have to be put aside because of their guest's special and strangely business-like interest in other matters. But, in their unfailing politeness and hospitality, they would invariably

do just that. I always had the feeling that, after we had left, when they were once again "en famille," they would summon forth those reminiscences that Marius had spurned as too personal, too idiosyncratic for his research and regale one another with tales of long-forgotten exploits, feuds, and romances.

In a way, it may have been the children who benefitted most from the storytelling bonanza which Marius' visits always unleashed, for their elders were not normally so loquacious about the past. I have no doubt that, after our departure, it was often the case that one of the children, tantalized by some allusion to the mysterious past, would tug at a grownup's sleeve and ask, "Dis donc, maman, qu'est-ce que vous alliez dire de notre grand'père lorsqu'il s'est sauvé dans le bois pendant la guerre? Racontez-moi ça, s'il vous plaît." Sometimes a surprising amount of pestering was required to induce the parents to open up. The women, at least the ones I knew, were not great talkers, or, if they were, did not devote much of their conversation to past experiences. On those few occasions when the children were able to loosen their mothers' tongues in my presence, they showed such rapt interest in what was being said that it was obvious they had never heard the tales before.

If the women were little inclined to gossip about the past, the men were even less so. Taciturn in the extreme, most of them barely opened their mouths except to respond, as briefly as possible, to a direct question. Perhaps alone amongst their own kind, they were more communicative, but with educated strangers, such as Marius, they were reserved, as if conscious of differences in social status and schooling. (They had gotten used to us, I suppose, because our obvious poverty made us "one of them.") We observed the same polite reserve on those occasions every summer when some Grande Dame or other from the city would drop in, bringing a bag of used clothing to a former cook or maid. What bowing and scraping these visits would induce! But this was hardly the cynical,

resentful fawning one might have expected under the circumstances. They seemed to be genuinely impressed by the Grande Dame's genteel (and sometimes condescending) manners, genuinely honoured by her presence, so that the visit would be grist for the gossip mill for a long time after her departure.

This is hardly surprising, since little happened in the lives of the people of the concession that might distinguish one day from another. Each season brought with it its own traditional patterns of behaviour, routines which had endured since the first days of the settlement. Geographic isolation, too, had played a part in encrusting these patterns by making the region virtually immune from outside influences or pressures to change. It would be at least ten years after our arrival in Charlevoix County before electricity and radio would reach into the furthest concessions or before cars would be seen with any regularity on the narrow dirt roads. Change, when it did come, would sweep out the old ways with the force of a tidal wave. How fortunate it was that Marius Barbeau and a few others, realizing what was about to happen, worked so assiduously to document that doomed culture.

SALMON FISHING — THE ILLEGAL KIND practised by the inhabitants of Saint-Urbain — in no way resembled the sport as it was practised by the wealthy members of the private sporting club that rented a nearby part of the river from the government. The local, illicit variety we had been told about sounded much more hazardous, more exciting, and we wanted to see what it was like.

One warm summer night, surfeited by talk and too intoxicated by the beauty of the nocturnal world to sleep, we decided that this would be the time for that salmon fishing expedition which Michel Fortin and his brother Edouard had been promising us. With our visitor we put a half-empty bottle of "whiskey blanc" into a paper sack and set off down

through the sleeping village, sauntering along in the heavenly radiance of the full moon, our echoing footsteps setting off a chorus of barking dogs and some startled cocks. Leaving the village behind us, passing by the last Indian huts, we clattered across the old covered bridge, which spanned a deep and narrow section of the river where it turned at an almost 90-degree angle. Beyond the bridge, the road rose abruptly and continued straight on for half a mile in the direction of La Décharge concession before disappearing behind the hills.

The old Fortin place lay along a slope above the road. The house itself was a large, rambling affair with a sloping roof and an attached summer kitchen. No dog barked as we approached the porch steps, no light shone from any of the windows. Small wonder. We had dawdled along the way, made dreamy and indolent by the beauty of the night, and now it was almost two o'clock in the morning, hardly an hour to be rousing people from their beds on such a frivolous errand. But we had come all this way, and our appetite for adventure was keen. We banged on the door. And banged and banged until a light suddenly appeared in the well of the staircase. Through the door window, I could just make out the rangy figure of a man descending the stairs, holding aloft a lantern. It was Michel.

"Qui est là?" he shouted, placing the lamp on the kitchen table.

As we shouted our names, he bent down to peer at us through the pane of glass. Reassured, he threw back the bolt and let us in. Not in the slightest annoyed by our nocturnal intrusion, he stood there yawning, dressed only in long white woolen underwear, one of his hands covering his private parts (out of deference to me). With his free hand, he shook our outstretched ones in welcome.

As soon as he learned of the nature of our errand, he shouted up the stairs, "Edouard, descend donc! Voila Monsieur et Madame qui veulent aller à la pêche!" And then, turning to us, "Asseyez-vous donc," as he pulled out chairs from the cluster around the kitchen table.

An interesting family, the Fortins. Orphaned while still in their teens, the two brothers and their two sisters lived together in the paternal house. Now all in their early forties, they had never married. Little was known of them; apart from regular attendance at church, they were rarely seen at social gatherings. None of the village girls had ever been courted by either of the Fortin brothers, nor had the Fortin girls ever encouraged the harmless flirtations typical of adolescence. Though they were part Indian, the Fortins did not mix with the small community of Indians living on the outskirts of the village. In summer, they worked the farm, all four of them; in winter, while the brothers were off logging for months at a time, the two girls would be left to look after the livestock. Given their renouncement of marriage, it is hardly surprising that coarse speculation of incest abounded. (Actually, incest was not an unusual occurrence in the village in those days. Indeed, we had hardly settled down in Saint-Urbain when we were told of a father who had seduced his fourteen year-old daughter. His house was pointed out to us, a big house perched high on the hill at the entrance to the village, the exterior painted a lurid orange, as though to flaunt the violence within. A few years later, the girl married a young man from a neighbouring village, burying her past under motherhood a dozen times over, and the house gradually faded to a benign shade of pink.)

Pulling our chairs up to the kitchen table, we produced the bottle of "whiskey blanc." The two sisters came shyly down the stairs to join us, their hair awry, old sweaters hastily pulled on over their long flannelette nightgowns. They were tall and bony like their brothers. The older sister, her straight black hair frizzed at the ends by a bad permanent wave, had the strong features, flat head and oblique eyes of her Indian ancestors. The younger one, though, was peculiarly attractive. The way her eyes rolled and the way she held herself, so straight, the line of her long neck one with her back, she put me in mind of a lovely, untamed colt. Ill-at-

ease and little used to strangers, she spoke hardly at all, and when we were not looking at her, I could feel her eyes on us, though she never once turned her head in our direction.

Michel heated some water over the fire and filled our glasses with the whiskey, hot water, and sugar. Shouting "salut!" and raising our glasses to each other, we downed the drink in a single swallow, as was the custom. It was delicious. The years have erased my memories of the conversation we shared, although I have no doubt that the Brothers Fortin whetted our appetites for the night's adventures to come with all sorts of tall tales about legendary salmon catches. Perhaps it was the liberating influence of the drink, but I did not find it at all odd to be sitting there in the middle of the night with two nightgowned women and two men clad only in their underwear, their "shameful parts" respectfully shielded from view.

Drinks downed, Michel got us to our feet with a clap of his hands and a hearty "On y va?" While the brothers went off to pull on some clothes, we said goodbye to the sisters and went out into the yard to admire the two black horses nuzzling each other by the fence. The moon was still high and shone brightly on the river beyond the fields across the valley. How thrilling it was to be alive and wide awake, the mysterious beauty of the night all around us and the promise of an illicit little adventure awaiting us.

The brothers emerged from the house, beckoning us to follow them to the barn, where they fetched their fishing equipment — a long pole, a bunch of old rags, a canister of oil, and a homemade spear. We shouldered our share of the burden and followed them across the road and down the field to the river.

On each side of the river, cliffs jutted some twenty feet high and here and there along the shoreline ragged bushes spilled half into the water. From under a cache of underbrush, Michel pulled an old rowboat half full of water, which he quickly emptied, turning the boat over and right-

ing it again immediately with a twist of his wrist. Taking some of the rags, he quickly dried the seats. Meanwhile, with the rest of the rags, Edouard was fashioning a make-shift torch by winding them around one end of the long pole. Then, laying the pole of the ground, he soaked it completely with oil and planted it firmly in a hold in the front of the boat. We watched the proceedings. When all was ready, Michel positioned himself in the front with the spear and waited for us to take our places on the two middle seats. Edouard, now wading in water up to his knees, then gave the boat a shove and hopped aboard, grabbing the paddle and propelling us into the current.

No sooner had we reached the middle of the stream than Michel leaped up to ignite the torch, his movements causing the boat to rock. (The river was extremely swift and deep at this point, way over our heads, and neither of the brothers Fortin knew how to swim.) Michel, still standing with the base of the burning pole braced between his two feet, grasped the shaft of the torch with one hand and the spear with the other. Edouard continued paddling furiously to keep us in the current. On each side of us, so close they seemed to be at arm's length, the cliff walls were brilliantly illuminated by the torchlight, Michel but a black silhouette against the flames.

For several moments, he bent silently over the prow, his face almost touching the churning water. Suddenly, without turning his head, he announced in a muffled voice, "Les voilà!" And there they were, indeed. At least a dozen fat salmon could be clearly seen as they moved towards the bright swath of light. We held our breath as Michel hoisted his spear and plunged it into the writhing tangle of bodies gleaming just under the surface of the water. For a moment he remained hunched over, bending and straining to get a purchase on his struggling prey. Suddenly, he lifted the spear into the air, holding it motionless for a few seconds, then, adjusting his grip on the shaft, he rucked his catch down a few notches to

a more secure position. Only then did Edouard rise up and grab the slippery, convulsing salmon, guiding it safely to the bottom of the boat. With one blow of his heel, he killed it and sat down again fast at the helm, for our boat was now racing wildly toward the rapids at the bend of the river. As he brought the boat once more under control, we watched the salmon make one more feeble surge toward freedom when removed from the spear. The fight abandoned, the fish lay glowing up at us from the floor of the boat — all 28 inches of him!

The brightness of the flames was ebbing, and, if we were to take another salmon, it would have to be immediately. Wasting no time, Michel set to work, and in a matter of seconds his earlier feat was repeated. With a triumphant laugh, he landed another superb specimen, even more magnificent than the first.

It was now urgent that we return to shore at once, before our little boat was propelled into the whirlpool at the foot of the bridge. With a piercing shout, Michel planted his spear deep into the riverbed, leaning upon it with his full weight, while Edouard, paddling furiously, gradually maneuvered the boat at right angles to the riverbank. Once out of the current, we were able to make our way easily to the shore by the break in the cliffs. There we disembarked, and the men beached the boat, camouflaging it as before under a mass of bushes. The following day, the brothers would return to drag the boat through the shallows back to its usual cache on their own property.

Although the brothers offered us both fish, we took only the smaller one, more delighted with the adventure itself than with the idea of profiting from it. Not that we disdained their generous gift. This was one salmon I would not soon forget, as special to me as if I had caught it myself.

As we shook hands all around, someone remarked that it was past four o'clock, and, sure enough, we could see the August moon fading in the first faint glow of dawn. As we trekked home the rising sun grew

steadily bolder, casting long purple shadows across the valley. Our passage through the village once again aroused the dogs and set the cocks to saluting the arrival of the new day. The clamour of their cries followed our footsteps, rising and subsiding until they were muffled almost completely by the abrupt little hill screening our house from the village.

Later that day, we made a meal of our trophy. There was far more of it than the three of us could eat, of course, and, as we had no ice box in those days, I pickled the remainder for a future feast.

EARLY ONE EVENING in late summer, we decided to take our visitor, Davidson Dunton, to a typical country wedding feast, so that he might at last experience some of that Charlevoix County hospitality and high times we had been telling him about. We had been invited to just such a feast — a double wedding, in fact — that very evening at the farm of Monsieur Lionel Bouchard up in the hills of St.-Hilarion. The three of us set off in high spirits, never for one moment imagining that the wedding party we were about to attend had a surprise or two in store for us.

That morning the Bouchards had married off both of their sons to two sisters, the daughters of their neighbours living on the other side of the hill. The party had been going full steam since then, and, by the time the three of us arrived, the men were drunk.

There must have been 40 people in the kitchen and still more about outside. A square dance was in progress, and the house shook from the shouting and stamping of feet. The older men, those who had managed to remain more or less sober, were sitting along the edge of the railing-less verandah, dangling their legs, puffing on their corncob pipes and spitting copiously into the yard below as they exchanged gossip about crops, livestock, and the like. Though balmy, the evening air carried a hint of the autumn coolness to come, bringing some measure of relief from the sweltering heat of the kitchen to the men assembled on the

porch, swaddled uncomfortably in their heavy black homespun Sunday-go-to-Mass suits.

At our entrance, all eyes turned to take in the three strangers, though the dancing continued unabated. The master of the house broke away from the crowd and came forward to bid us welcome. Madame Bouchard directed us vaguely toward some empty chairs, but before we could take our seats, her husband seized my arm and propelled me onto the dance floor and begun whirling me to and fro, flinging me about in all directions in time with the caller's intricate choreography. So boisterous was the execution that I might have done myself injury had it not been for the expert guidance of my partner, all the more astonishing considering his rather advanced state of inebriation.

After the set was over, there was a short pause to give a rest to the caller and his musicians. The men wandered outside. Milling about in the waning sunset, which still gilded the mountaintops, they began passing a bottle around. I would have loved to escape the oppressive heat of the kitchen and join in their good-natured talk, but it would have been unthinkable for a man to offer a woman a drink, and no respectable woman would have expected him to do so.

With the kitchen now half empty, I was finally able to meet the brides and their families and admire their homemade wedding finery. The gowns were elaborate creations trimmed with ruffles and bows and made, as were most wedding dresses of the time, of a fabric called "peau d'ange" (angel skin), a soft, delicate imitation silk material. The shoes were of white satin, as was the little bag that dangled from each bride's white-gloved wrist. (I used to wonder what they carried in those little pouches. Prayer missals or rosaries probably, surely not cosmetics.) On important occasions such as this, it was the custom for a young woman to cover her entire face with white powder; no other artifice, such as lipstick or mascara, was ever applied. With their white gowns and accessories and their

stark white faces, the two young brides hardly looked the ideal matrimonial choice for young labourers or farmers, who would be needing robust, energetic mates to share in their life-long struggle for survival. Fortunately, these "death masks" would come off once the festivities were over, and the true ruddiness of their naturally healthy complexions would reappear.

The two young couples would not be starting married life in St.-Hilarion, as generations before them had done, for two years earlier the two young husbands-to-be had gone to Montréal to become dock-workers. Their two older brothers, having opted to help their father on the family farm, had been given enough land to build their own houses when they married. But when it came time for the younger boys to marry, family land was a a premium, so they were squeezed out.

Actually, these two young men had become part of a growing exodus toward the cities from nearly all the villages and concessions of Charlevoix County, where families had grown too large to be sustained by the region's small farms. Indeed, throughout the Depression years, so many young men were to join their fathers and brothers in Montréal that a close-knit community of expatriates, called Little Charlevoix by many, sprang up in the city's east-end district of Hochelaga. Despite the economic imperatives that drove them to the city, they did not embrace city life unreservedly; their hearts were still in Charlevoix County, so much so that most would return there each year during the winter months when the Montréal harbour was ice-bound and idle. Like our two bridegrooms from St.-Hilarion, these young men invariably married Charlevoix girls. And now, decades later, the grandchildren of these expatriates are returning nostalgically to the region to build summer chalets in the birthplace of their ancestors, many of them hoping to live out their declining years there.

As darkness gathered, the lamps were lit and placed safely out of reach of the rolling mass of dancers. Many of the men had begun losing control of their limbs and so their ability to follow the caller's directions.

Now and again a girl would go flying off course, landing with an ungain-ly "plop" on the knees of one of the guests seated along the wall, her flight accompanied by great gusts of laughter. Little by little, the atmos-phere of gaiety was giving way to one of volatility and tense foreboding. There was a feeling in the air that anything could happen, that passions were not in control. The old folks began to fidget and glance about, clear-ly uneasy. As another dance set, even wilder than the last, came to an end, Madame Lionel tiptoed up to her husband, whispering urgently and ges-turing in the direction of their newlywed sons, who were shouting at each other in drunken fury across the room.

Monsieur Lionel was a short, stocky man, powerful as a bison through the neck and shoulders (a legacy, no doubt, of his younger days as a logger, when he often had to portage a heavy canoe on his shoulders for miles at a time). Tipsy, he stood there a moment listening to his wife, his thick black brows furrowed, none too sure of what he should do to end the scuffle. Swaying slightly, his slanting black eyes mere slits, he looked the picture of those Russian moujiks of Czarist days, as depicted on the cover of my old copy of Gogol's *Les Ames Mortes*. Suddenly, Lionel strode toward one of his sons and, turning him about, delivered a blow to the side of the young man's head, causing him to lose his balance and crash heavily to the floor. Only momentarily stunned, the son leaped to his feet and threw himself, arms windmilling wildly, upon his father, who by this time had turned his attention to the other son.

Completely taken aback by this outpouring of violence, the onlook-ers stood stupefied, unable to react. We stared as the three men struggled, thrashing and pummeling each other. As women screamed hysterically, several of the men tried to drag the father away from his sons, who were now both straddling him in the middle of the kitchen floor. As the churn-ing tangle of limbs rolled part way under the table, lifting it clear off the floor, the lantern began sliding crazily. A cry went up: "La lampe, la

lampe, attention!" One of the onlookers managed to catch it just in time and held it aloft out of harm's way. The rest of us pressed ourselves as flat as possible against the walls.

During all the commotion, Madame Lionel had quietly slipped out to fetch a pail of water from the rain barrel at the end of the verandah. Returning with the dripping bucket, she paused a moment, took careful aim and sloshed the contents over the three brawlers. The effect was immediate and salutary. Thoroughly drenched, the three men staggered sheepishly to their feet, shook themselves off, and erupted simultaneously into gales of laughter. In a matter of seconds, everyone in the place joined in. Still laughing, Lionel went off to fetch the whiskey bottle, beckoning his sons to follow him outside in the darkness for a reconciliation drink. Not long after, Lionel fell flat on his face in the grass, dead to the world, where he remained for the rest of the veillée. When one of us suggested going to retrieve him, Madame Lionel clucked, "Laissez-le là. Il est ben là où il est."

By the time we were ready to leave, things were slowing down a bit. Madame Bouchard was sound asleep in her rocker, gently snoring. There was a square dance set still in progress, but the dancers were fewer in number and showing signs of fatigue. As we stepped over the threshold into the darkness, we stumbled over several young men sprawled heavily in sleep on the verandah, despite the brisk nip of approaching autumn in the air. It was a heavenly night and the moon was beautiful. When we arrived home, taking one last look at the sky before going in to bed, we were favoured by a spell-binding display of Northern Lights — such an inadequate name! In the Saint-Urbain valley, the aurora borealis was a familiar enough sight on late summer or early autumn evenings, but nothing we had seen could rival this night's spectacle — two immense, ever-expanding curtains of brilliantly-coloured shimmering light, wafting across the heavens to form a double circle, a rosace.

The week following the wedding, we went back to St.-Hilarion to see how the Bouchards had survived the festivities. Since it was late afternoon when we arrived, almost the supper hour, we were surprised to find Monsieur Lionel outside by the shed intently examining the hooves of one of his horses. Nearby, one of his sons was busy activating the bellows of a crudely-made forge. They straightened up to greet us, grinning broadly with outstretched hands.

We joshingly inquired about their recovery from last week's fracas, saying to Lionel, "J'avais peur que vous alliez mourir après une telle douche d'eau froide!"

At this, he laughed. "Ouais, ouais, c'était fameux, hein? Ma femme n'a pas 'frette aux yeux,' comme dirait le gars. J'étais trempé jusqu'aux os, mais ça m'a rien fait pantoute. J'étais bien trop 'chaud,' j'étais 'chaud' pour de vrai. Mais, quand on marie deux fils, c'est ben le temps de fêter un peu, pas de mal à ça, hein? Eh, dites donc, vous savez les nouvelles?"

"Non, quelles nouvelles?"

"La femme d'Alzarius est morte à matin. On est venu nous le dire à midi. Elle est morte en couches."

"Oui? Vous ne me dites pas! Pauvre Alzarius. Avec toute c'te trâlée d'enfants, qu'est-ce qu'il va faire? Il est parent avec vous, Monsieur Lionel?"

"Ben, oui, c'est mon beau-frère; sa femme et ma femme sont deux soeurs. On s'apprêtait à y aller pour veiller là-bas quand je me suis aperçu que la jument boîtait. Une malchance. Joseph et moi, on va essayer de 'manigancer' un sabot pour ce voyage, et demain on ira à la Baie. En attendant, allez donc à la maison voir la créature," he said, gesturing toward the kitchen and his wife.

Inside the house, ready to leave as soon as her husband finished harnessing the horse, Madame was bustling about giving orders to the older children, one of whom was setting the supper table. A delicious aroma arose from one of the pots simmering on the stove. Glancing into it, I saw

that it was a stew of salt pork, onions, and potatoes. In the middle of the table was the usual round bowl of black molasses. Had the hour not been so early, I would have been sorely tempted to accept Madame's invitation to stay for supper.

Without skipping a beat in her preparations, Madame began to give an account of her sister's death. Though she displayed no outward emotion, her swollen bloodshot eyes betrayed her grief.

"Elle n'avait pas encore trente-cinq ans, vous savez, ben trop jeune pour mourir, pas vrai?" Indignantly, she wheeled to face her youngest daughter. "Emilia, t'as pas fait le thé! L'eau est bouillante, et tu fais rien! Attention, c'est pesant, tu peux t'ébouillanter...." Turning back to us, she continued, "Ouais, Monsieur, Madame, pas encore trente-cinq ans. Et Alzarius avec huit enfants sur les bras. Heureusement que le petit est mort avec."

Then, in a low voice, so the children wouldn't hear, "Il paraît qu'il avait la tête grosse comme ça. C'est pour cette raison, d'ailleurs, qu'Anna est morte. La sage-femme n'arrivait pas à bout de le faire sortir ... c'est pas drôle, des fois. Anna avait toujours des couches difficiles, la pauvre."

She could no longer keep back the tears. Choking with sobs, she brought her apron up to hide her face, and for several minutes the silence in the kitchen was broken only by the muffled sounds of her grief.

The two littlest girls, who had been staring at us, their thumbs stuffed into their mouths, now began to cry loudly at the sight of their mother's distress. At this, Madame Lionel ceased weeping abruptly and turned on them.

"Voulez-vous vous taire, vous autres, espèces de malvenants!... Excusez-moi, Monsieur, Madame, Je suis encore toute bouleversée. Vous comprenez ... elle était la plus jeune de la famille, et quand elle était enfant, c'est moi qui en avait soin; enfin, c'est moi qui l'a élevée. C'est un dur coup...." She sat down heavily, wiping her cheeks with her apron. "Il faut l'accepter, je l'sais, mais ça va me prendre un peu de temps ... et dire

qu'elle a eu huit enfants sans en perdre un. Il faut croire qu'elle était épuisée. Mais c'est la volonté de Dieu, et elle est maintenant au Paradis."

Rising abruptly from her chair, she went to the kitchen door and leaned out. "Joseph, n'oublie pas de soigner le veau avant qu'on parte! Et traîne pas comme ça à rien faire, les vaches sont au clos qui beuglent!"

We got up to go, refusing once more her kind offer of supper, saying that we would probably see them later that evening at Alzarius' place. As it was still early, we decided to go straight there to pay our respects.

As we approached Alzarius' place, we could see him feeding his foxes up on the hill across the road from the house. He hailed us and made signs for us to join him there. Three or four small children rushed out of the house and followed us up the hill, gamboling like puppies and swirling about us on all sides. They were attractive children, winning in their irrepressible gaiety and unusual in their blonde, blue-eyed good looks. In no way did they resemble their father, who was almost Indian in appearance, but they had inherited his merry temperament and love of fun.

A man of infinite patience and good humour, Alzarius found it impossible to discipline or reprimand his brood, so that they were growing up like a band of forest animals, living in a state of almost carefree anarchy. Though not short on love, Alzarius was chronically short on time—so much to do. Although the two older boys, then only nine and ten years old, did help with the lighter chores, the children were not really expected to be of much use around the farm until they left school at the age of twelve. (When Alzarius himself died some three years later, I could not help being glad that these sweet wild creatures had enjoyed such happy childhood years.)

As we shook hands with him and expressed our condolences, Alzarius' welcoming smile faded from his face. Hanging his head, he muttered, "Ouais, ouais," he kept muttering, "qu'est-ce que je vais faire avec une gang d'enfants pareille? Ma belle-soeur, elle va venir à soir pour

rester quelque jours, mais après? Peut-être que Madame Agnès — vous savez, la cousine de ma mère qui reste chez mon oncle au deuxième rang — pourra nous dépanner.... Elle est ben laide, mais pour le travai, elle est ben smatte, d'après ce qu'on dit."

When we sympathized with him, he pursed his lips, assumed a deeply thoughtful air and, with a defiant thrust of his chin, remarked, "Je peux ben me remarier, vous savez. Je suis encore jeune ... et ben capable."

He looked at us closely. Then, satisfied that we had understood his veiled reference to sexual prowess, he smiled. His good humour had returned and he directed our attention to the cage next to us, exclaiming, "Regarde le beau renard, c'est pas mal, ça, hein? "Garde la queue." Again, he gazed at us earnestly, anxious that we should properly appreciate the beauty of his prize silver fox.

We left Alzarius crooning to his foxes and went down to pay our respects to the deceased. As was the custom, the friends, relatives, and neighbours come to mourn had all gathered in the kitchen. Normally untidy and grimy: today the kitchen was in perfect order and shining, scrubbed and lathered into respectability by the efficient Madame Eloi. Knowing of her long-suppressed desire to "mettre de l'ordre là-dedans" where Alzarius' household was concerned, I felt like giving her a wink as we shook hands. Madame Eloi had seen to it that even the children were spruced up for the occasion, their adorable little faces satiny-clean. Stiffly seated on the stairs, they appeared fully aware of the solemnity of the occasion, though their eyes often danced with excitement. Madame Eloi, their ferocious aunt, had instructed them they could stay up past bedtime only as long as they behaved themselves. Whenever a newcomer arrived and made his way to the bedroom off the kitchen where the body lay stretched out in death, one of the children (they had agreed to take turns) would follow the visitor, staring up into his face while he knelt praying before the corpse, curious.

The death chamber was quite dark. The shades of the two windows had been pulled tightly down, so that none of the late afternoon sunlight could lighten the sombre scene. There she lay — there *it* lay — the corpse of the former Anna Bouchard, wife of Alzarius Tremblay. Now only a lifeless shape under the white sheet, she lay on the bed where she had endured so many confinements. The pale oval face, so sun-tanned from years of harvesting (she had tilled the fields at her husband's side all through this, her last pregnancy) was framed by coils of light brown hair. Once, she must have been as fair as all her children.

At my side, one of the little boys put out his hand and touched a strand of his mothers hair, turning to look up at me with an angelic smile. The reality of this death did not imprint on his childish mind. This was a game to him, or perhaps he believed that his mother was simply ill and would recover one day soon. Adding to the dreariness was the pungent odor itself; flowers had not been brought in to mask the scent. (I was glad, though, that no attempt had been made to dissimulate the natural mask of death with some of the cosmetic "refinements" that later came into vogue.)

I turned to leave. Drawing the boys out of the room with me, I saw a figure in black, kneeling in a corner, gazing up at a primitive crucifix on the wall. It was old Madame Laforêt from Saint-Urbain, who loved death wherever it struck. Because this peculiar passion of hers was well known to everyone, she was often called upon to "veiller le corps," standing vigil through the night if need be, so that the exhausted members of the grieving family could get some rest.

She particularly seemed to relish the deaths of babies. Whenever she announced such an event to me, she would smack her lips and chuckle ominously. "Ouais, il est mort, le petit d'Isabelle. Je savais il y a longtemps qu'il allait mourir, heh, heh." And her protruding chin would bob up and down, leering with smug satisfaction. Babies often died in those years from lack of prenatal care, so that Madame Laforêt had ample

opportunity to indulge her ghoulish pursuits. Actually, her peculiar aberration was considered a useful service by many in the community, for she was ready and on call at all times. No one seemed in the slightest put off by her morbid air, except me. I found her frightening. With her toothless grin and long pointed chin, which curved up to meet her prominent falcon-like beak, she looked very much a witch and her way of staring at you with piercing black eyes was unnerving in the extreme. Turning in my direction, the old lady gave me a silent nod, a malevolent, chilling look that hastened my exit.

By this time, Alzarius had removed his fox-tending clothes and joined his guests in the sweltering kitchen. Clean and natty in his Sunday suit, he was beaming with pleasure at the sight of so many people gathered in his little house, an event that was rare in his monotonous life of toil. Much later, after we had all gone, he might permit himself the luxury of mourning his wife (indeed, after the funeral, he would be inconsolable for several weeks). But, for this evening, he meant to enjoy his role of principal mourner and host. He could not repress his natural good spirits nor his delight in communication. Like a sparrow, his head would turn quickly from one person to another, his black button eyes eagerly demanding sympathy and affection. His simplicity was disarming, and one could not help liking him, though I often wondered how a grown man with eight children could have remained so child-like and naïve. His neighbours thought him a fool, but they all agreed that he was a "bon gars, toujours prêt à rendre sarvice."

They were there, gathered around him in his time of tribulation and need, offering him moral and physical support. The women of the concession, who had been cooking and baking all that day, had brought quantities of food and the men had divided up the chores, so that all would run smoothly for the next couple of days and Alzarius would have a brief holiday, at least until the funeral.

It was going to be a long night. The men had filled their pipes, and as they smoked pensively, the pungent odor of the homegrown "tabac canadien" permeated the kitchen. (For which I was not ungrateful, as the slightly acrid smoke was helping to dispel the odour from the bedroom.) Highly polished spittoons had been placed about the kitchen floor, and every few moments the low buzz of conversation was punctuated by a short percussive "splat" as a jet of tobacco juice found its target.

Madame Eloi now sat, shoulders hunched and eyes staring vacantly; she had had a long day, and it was by no means over. Her thoughts turned to her own home. Although her eldest, Alice, had remained at home, it worried her to leave Blanche without the constant attention she was accustomed to. Besides, without knowing the meaning of the word, she was bored; her hands embarrassed her by their idleness. She longed to return to her own little house and those familiar duties which never ended until she fell into bed. Eloi could spend the night if he so desired — and it was to be expected under the circumstances, he being Alzarius' only brother — but she herself would be leaving at eleven o'clock, as soon as she had served the "réveillon." She glanced at the clock and sighed. Then, seeing me standing uncertainly at the kitchen door, she got up from her chair, urging me to take her place by the stove. It was a kind gesture I would have willingly forgone, as the heat in the kitchen had grown oppressive. Pots and casseroles simmered and boiled on the old wood stove, dispensing warmth we could have all done without on this late August evening, but tradition decreed that the mourners must be fed.

More visitors continued to arrive and squeeze themselves into the kitchen. As the evening wore on and seating became ever more scarce, boxes were brought in and planks laid over them to accommodate the new arrivals. Seated near the window, Eloi Tremblay, his eye trained alertly on the curve in the road, was taking it upon himself to warn everyone of each new arrival, crying, "Voilà Elie et ses garçons," or "C'est

Main-sale et sa femme." As each visitor approached, he'd jump up from his chair and go out into the yard to help tie up the horses or, for those intending a longer visit, help with the unharnessing. Like his brother, Eloi was taking much vicarious delight in the occasion. He hadn't enjoyed such an evening since the death of his mother-in-law, when he had driven his whole family over to Ste.-Agnès to spend three days, leaving Alzarius in charge of the livestock.

Main-sale stepped into the kitchen, grunting a perfunctory "salut" in the general direction of all assembled. Taciturn in the extreme, he would utter nothing further until "bonsoir" as he headed out the door. A tall, bony man, his clothes hung on him in folds and his lantern-jawed face was almost always devoid of expression, revealing nothing of what he might be thinking. (Was he stupid or just sparing of speech?) His real name was Néré Vandal, but he was called Main-sale because his hands — not only his hands, alas! — were always grimy. In fact, so accustomed was everyone to the sobriquet that he was often called Main-sale to his face, and he himself had never shown any sign of objecting to it. The entire Vandal family had an unwahed, unkempt look, which was hardly surprising considering the extreme poverty in which they lived. Their house, a tar-papered shack, had no running brook nearby; whenever they needed water, they had to harness up one of the horses and trundle a barrel down to the little stream that ran under the bridge. This effort went a long way in explaining the family's appearance.

The scorn that the fastidious Madame Eloi heaped upon this family did much to discourage any empathy toward them or curiosity about them I might have felt at the time. Throughout our stay in La Décharge, Main-sale and his family remained pretty much of a mystery to me. I deeply regret that now, for when I renewed my acquaintance many years later with Eloi's daughter Alice, who had married Néré, the eldest son of Main-sale, I found him to be most "sympathique," a good-humoured,

gentle man with a deep love of children and animals. His marriage to Alice, who had apparently inherited her mother's passion for order and cleanliness, had also brought about a miraculous transformation in the family's hygiene habits. On the afternoon of my visit, I was delighted to note that Néré, just in from working in the fields, smelled pleasantly of new-mown hay and nothing else. (Thinking back on those days decades ago, I now wonder with regret what kind of a man his father had been. Unfortunately, the chance to find out has passed forever, for Main-sale's house has since fallen to ruins and all his children have scattered to the four winds. Only his son and namesake, Néré, remained in the concession, eventually taking over Eloi's farm.)

With much scraping of chairs and shifting of bodies, we made room for Main-sale and his wife, Main-sale going to sit among the men, his wife among the women. As at any other veillée, the men and women were segregated and only rarely would any conversation spanning the gender groups take place. A man and woman might talk to each other only to give or take an order ("Arthur, rentre-moi du bois!") or settle a question or dispute ("Dis, Marie, ça fait-y trois ou quatre ans que ta tante est morte?" "Voyons, ça fait au moins dix ans déjà, tu le sais ben!"). As soon as the order was executed or the issue settled, the members of each sex would return immediately to their segregated conversations. I often felt a trifle cheated at being shunted off with the "womenfolk," as by now I had grown more than familiar with the chatter typical of such gatherings. Straining to catch snippets of conversation from the male enclave, I used to wish my ears could stretch clear across the room.

On this particular evening, however, I was to be far from bored by the ladies' conversation. With the corpse of Madame Alzarius uppermost in our minds, the women waxed nostalgic about other deaths, accidents, and catastrophic illnesses they had experienced or heard about. During these gruesome recitals, I was particularly struck by the matter-of-fact,

almost casual manner in which they related their stories. To them, sickness and death, though heartrending, were such common occurrences that they had become little more than banal, everyday events, of no lasting importance. I must admit that I found their uncomplaining acceptance of calamity admirable, even though ignorance and superstition may have been partly responsible for their fortitude and stoicism.

And I marvelled at the almost total absence of grief, or at least displays of grief. I watched Alzarius as yet another neighbour came up to him, offering his condolences, in a hushed voice and gravely clasping his hand. As before, Alzarius rolled his eyes heavenward, as though conferring upon God the task of translating the immensity of his sorrow to the man who stood before him. These gestures had been so often repeated throughout the day that they had become an automatic accompaniment to the visitor's handshake, the unthinking re-enactment of ritual. He seemed almost to relish his role as the newly bereaved widower, enjoying the special attentions of neighbours who normally gave rather short shrift to his flights of fancy and outbursts of emotion. In his undisguised eagerness to rejoin the conversation, where he was the center of attention, he would quickly steer the new arrivals to the bedroom, leaving them there alone for the obligatory moments of contemplation before the bier, while he himself ducked back to the kitchen to pick up the threads of an interrupted story.

Madame Laforêt, abandoning for a moment her vigil in the death chamber, now appeared at the kitchen door. The power of her personality caused all eyes to turn in her direction and rebuked all idle chatter. For a moment, at least, the company was reminded of the reason for their visit. As the old woman surveyed the kitchen in search of a chair, the mourners stared in silence at the floor. Hoping to end the uneasy state of suspended animation — and seizing with relief upon this diversion as an opportunity for us to leave gracefully — I leaped to my feet

and offered my chair.

Alzarius came out into the yard to see us off, once more breaking into lamentations, rolling his head mournfully from side to side, his eyes downcast. We made him promise to stop in and see us on his next trip to the village, to which he replied, "Ah, je sais pas quand ce sera. Il faut que je m'occupe de trouver une gardienne pour mes pauvre orphelins. Mais, je vous verrai, je vous verrai.... Marci de vot' visite!"

He did indeed come to visit about a month after his wife's funeral. We were amazed at his joyful air, for we had heard stories about the anguish and deep, paralyzing depression that had afflicted him in the weeks following her death. By all accounts, Alzarius had gone berserk at the cemetery and thrown himself onto the open grave with wild cries of despair. His brother Eloi had been so alarmed by this and by the black depression which followed that he actually suggested that the doctor from Baie-Saint-Paul be called. This extraordinary proposal, coming as it did from Eloi, must have had a sobering effect on Alzarius, because shortly thereafter his depression began to lift. For a while he lapsed into a quiet, almost bemused state, but, after a week or so of dreamy inactivity, he gradually resumed his normal busy routine.

With Alzarius busy again out and about the farm, the care of the house and children were given over to the capable hands of his wife's "ugly cousin" (as Alzarius had uncharitably but accurately described her). What a pity she did not stay longer than a few months, for, in that short time, she managed to bring some semblance of order and cleanliness to the household, such as had not existed even when Madame Alzarius was alive. After a time, however, her services were no longer considered necessary, for Alzarius did not wait long before remarrying.

Alzarius' visit on this occasion coincided with his meat run — every week he would go from house to house distributing meat from locally butchered animals to customers throughout the concession. And such

tough, inedible meat it was! As our house was at the very end of his run, we usually found little to interest us among the remaining scraps, though he would usually have kept back a small piece of liver. But even if he had nothing at all to offer us, he never failed to stop in for a chat. I can still see him sitting there in our kitchen, his chair tipped back precariously against the table, his white butcher's smock spattered and streaked with blood, taking his ease with these congenial outsiders who showed such interest in whatever he had to say.

We were happy to see that, indeed, the anguish and doldrums of his mourning period were apparently behind him. He seemed a man rejuvenated, his gaiety once again so infectious that we found ourselves laughing at everything he said, much amused by Alzarius' habit of interrupting all talk to turn his gaze to the window whenever a cart or carriage would approach the house. (We did this ourselves.) He would peer intently out into the road, squinting against the sun and conjecturing endlessly about who might be coming and why. He knew that he could always count on us to appreciate his good-natured gossiping and nosiness, for we were just as curious as he about the doings of our neighbours. As in most small communities, everyone knew everything about everybody! Even down to the most insignificant details of their lives. For instance, we had been in the habit of bathing "au naturel" every noon when the sun was hottest in the tiny brook behind our house. This spot, a deep hole in the stream bed, was surrounded by tall reeds and thick bushes, the perfect foil for prying eyes. We thought our daily ablution were just our clever secret, until a neighbour dashed that illusion during an innocuous conversation about trout fishing. Wishing to share with us the secret location of a plentiful cache of trout, he remarked, ingenuously, "Vous savez où il y en a beaucoup? Juste là où vous vous baignez." After a time, of course, we learned to accept our neighbours' friendly curiosity about our lives as just part of country ways and indeed, we

became just as nosy as our neighbours.

Seeing what a good mood he was in, I boldly asked Alzarius whether he had given any thought yet of marrying again. If for no other reason than to give his poor children a mother. Any shyness I might have been feeling about asking such a forthright question was quickly dispelled. From the look of things, he had been waiting for this opportunity to tell us what was uppermost on his mind.

Nodding his head in agreement, he said, "En effet, Madame, vous avez raison. J'allais justement vous raconter ça. D'abord, c'est pas normal pour un homme de vivre sans une femme à ras lui. La nuitte surtout, c'est pas mal ennuyant. J'ai le sang chaud aussi.... Je suis encore vert et, commes vous dîtes, les enfants ont besoin d'une bonne mère pour s'occuper d'eux. Alors, depuis un peu de temps, je cherche ici et là, mais c'est pas facile, hein?" He paused, as if to reflect on his dilemma. "Vous savez, ce qu'il me faut, c'est une bonne créature, pas trop jeune, pas trop vieille non plus. Et pas trop laitte surtout. On m'a parlé justement d'une veuve au cinquième rang de St.-Hilarion, et samedi dernier j'y suis allé et j'ai passé un bout de soirée chez elle. Elle doit avoir dans la trentaine plus ou moins, et elle a trois enfants dans le bas âge. Je vas dire comme le gars, elle est ben smatte et tient ben sa maison. Elle m'a montré une armoire pleine de couvertures de laine de sa propre façon et une autre remplie de confitures. A part ça, il y a une vache, un veau, et un cochon qui doit péser dans les 200 livres. Une bonne affaire toute réglée, mais ... mais...." A full stop. Obviously perplexed, he sat still and gazed straight ahead, as if puzzling through one of Life's major mysteries.

"Bon, continuez, Alzarius," we urged. "Qu'est-ce qui ne marche pas? Vous ne l'aimez pas, peut-être?"

"Non, c'est pas ça," he said, scratching the back of his neck. "Elle est ben d'adon, ben aimable et douce. Elle a de belles façons, je peux pas dire le contraire, mais...." Once again, he cast about for the words to tell us of

his dilemma. His mind made up, he tipped his chair forward, and resumed his revelations with great earnestness. "Bon, je vais vous le dire. Il y a une chose que j'aime pas chez elle.... Elle a des têtons gros comme ça!" (With his arms, he traced an enormous circle in the air to illustrate the size of her breasts.) "C'est une affaire terrible, ils sont gros comme des melons!"

Having revealed the worst, he let his arms drop to his sides heavily. His head drooped. We sat silently, too, impressed by the thought of those 'melons.' After a moment, he got out his pipe and filled it, lit it, and automatically looked around for a spittoon. I got up and handed him an ashtray. "Marci," he muttered, distracted. Then, as though inspired, he addressed me.

"Madame, vous croyez pas que je pourrais lui acheter un corset? Est-ce qu'on n'en vend pas de toutes les grandeurs?" I assured him that, of course, any woman of any size could be fitted with a corset; he need have no worries on that score. And, if he did not want to order one from the Eaton's catalogue, I knew of a store in Baie-Saint-Paul which specialized in women's underwear.

He gazed at me, grateful for my "pearls of wisdom." Now he could think seriously about proposing marriage to the widow. "Même si ça coûte cinq piastres, ça vaudra ben la peine, un bon corset."

It was only after he had left that it came to me why he had chosen me as his confidante in this particularly sensitive matter. I thought back to that time when Alzarius had accidentally seen me wearing only a brassière and knickers. At the time, we were living at Eloi Tremblays'. I had just taken my sponge bath up in our attic room and was dressing when Alzarius' booming voice called up from downstairs that he had some advice to ask me. Though I shouted that I would be down in a moment, he apparently couldn't wait. Before I could throw on a dress, his head appeared at the head of the stairs, peering at me through the bannisters.

I cried out, "Allez-vous-en, tout de suite, Alzarius. Vous ne voyez pas que je ne suis pas habillée?" But the great oaf just stood there, staring at me, while I covered myself with whatever was handy. Retreating down the stairs, he shook his head uncomprehendingly and muttered, "Qu'est-ce que ça peut faire, ça? Les femmes sont toutes faites pareilles." I don't wish to suggest that there was anything malicious or lewd about the man; he was simply candid and naïve. All the same, I doubt that until that day he had ever seen a woman in a brassière, as his first wife was flat-chested. No wonder he had thought of me when the idea of a corset for the widow had come to his mind!

Dear Alzarius. He was one of my favourites. He did marry the widow but whatever happiness he enjoyed in this second marriage was short-lived, for he died a few years later.

Jori Smith, *Jean Palardy*, n.d., graphite, Collection of National Archives of Canada. Negative # C-143525.

Alicia Johnson, *Jori Smith*, 1998, b/w photograph (37 x 54 cm). "Alice Johnson, a young Spanish photographer, took this of me sitting in this crowded one-room apartment I call my studio. Everything is crowded — the walls with paintings, the floors with rugs and more often than not with people too."

POSTSCRIPT

Readers who may well be asking, "But what happened afterwards?" will be comforted to know the same question was posed by the publisher. In reply to the request for additional information about how she came to write the manuscript and how her visits to Charlevoix County came to an end, Jori Smith provided the following:

"In the very late autumn of 1969, realizing my mother of 97 years might not last the winter, I decided to find an apartment near the government-sponsored Convalescent Insitution, where she lived in Montréal. Upon settling there, and unable to paint, I decided I would write down what I remembered of those wonderful years I spent with Jean Palardy in Charlevoix County. I enjoyed recalling this unique experience and am glad I did it then at the age of 63 while I still remembered clearly those happy times.

"After the death of my mother inthe month of March 1970, I returned to Senneville and resumed my life as a painter.

"I now marvel at the total recall and of how we fitted in to that life so different from our own. I feel, re-reading it, the same affection and sympathy I felt then, so many years ago, for those kindly, simple people who accepted so benignly our strange ways. I smile remembering them.

"Jean Palardy and I bought the little house in Petite Rivière, Saint François, in 1940 but immediately after, Jean joined the National Film Board and never again spent the summers in Petite Rivière, as I continued to do for almost thirty years, always remaining in intimate

contact with not only my immediate neighbours but all those old friends in different concessions in Charlevoix County. It was only in 1970, when I was expropriated, that I regretfully left Charlevoix for good, only occasionally returning for brief week-end visits."

PLATES

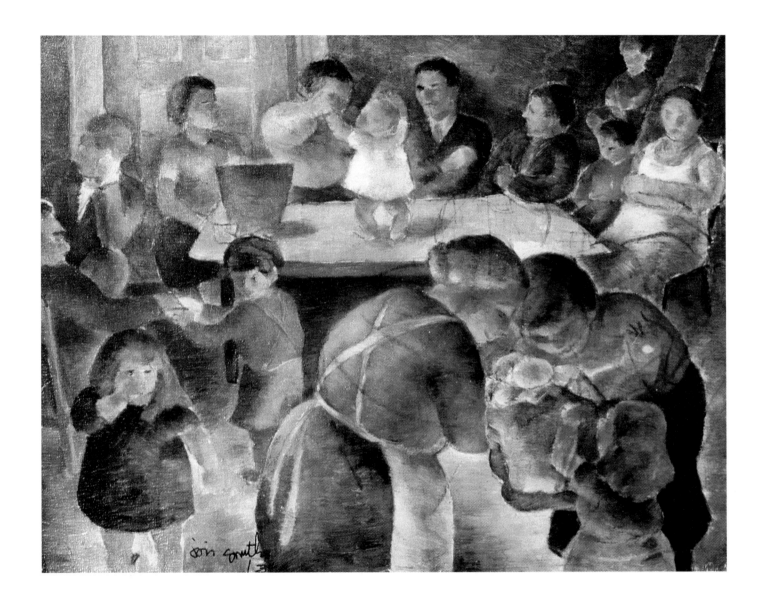

I Jori Smith, *Véillée chez Eloi Tremblay, St. Urbain*, 1934, oil (20.8 x 30.5 cm). Collection of Leonard and Bina Ellen Art Gallery, Concordia University. Photograph by Maria Horyn. "These gatherings were very frequent, at least one a week, often two. Jean was such an entertaining, amiable man, very much at ease with everyone, and so the neighbours returned often. Poor Madame Louisa, how tired she must have been from these evenings."

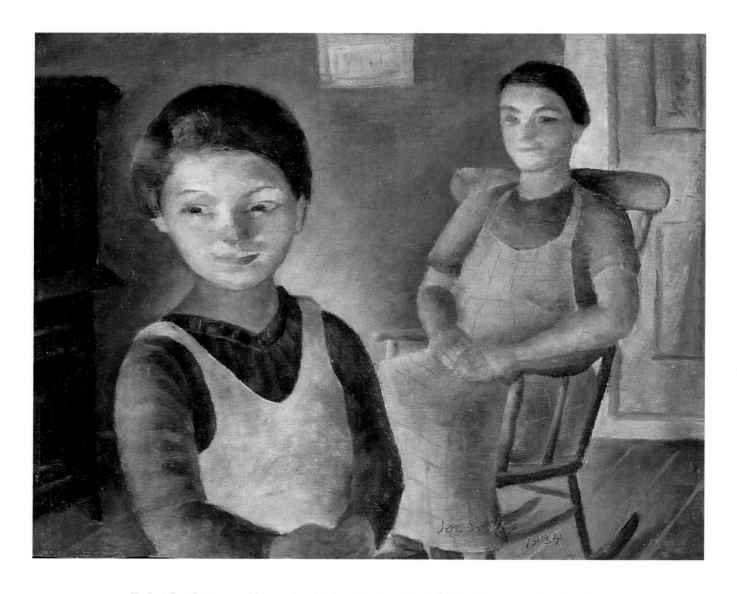

II Jori Smith, *Rose and her mother, Madame Louisa, wife of Eloi Tremblay,* 1934-35, oil on board (23.2 x 30.2 cm). Collection of Dr. Joseph Stratford. Photograph by Brian Merrett Collections Imaging, Montreal. "There were three daughters ranging in age from 8 to 12. Alice and the youngest, Rose, were most helpful in looking after the needs of Blanche, crippled by infantile paralysis, who spent her days in a rocking chair beside the fire."

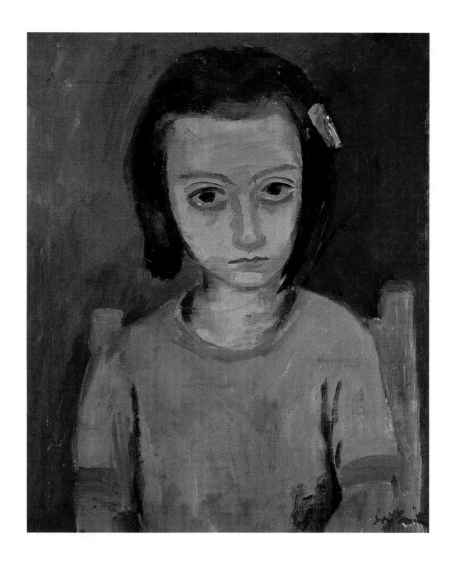

III Jori Smith, *Rose Fortin*, 1935, oil (50.8 x 40.6 cm). Collection of Talbot Johnson. Photograph by Brian Merrett Collections Imaging, Montreal. "One of my early paintings of children. I loved to paint portraits and as the men and women were always too busy to pose for me I was only too pleased to use children as models and to discover how much they seemed to enjoy sitting for me."

IV Jori Smith, *Church at Baie St. Paul*, 1930, oil (18.8 x 24.1 cm). Collection of Dr. Joseph Stratford. Photograph by Brian Merrett Collections Imaging, Montreal. "A very large church indeed, almost a cathedral, and it served an enormous parish — all the concessions in the valley — and attendance was steady, constant and devoted."

V Jori Smith, *La Rivière du Gouffre*, 1930, oil (21 x 33 cm). Private collection. Photograph by Maria Horyn. "These very small sketches were done outside standing with our small boxes. We had to work fast in that cold weather. I soon abandoned land-scape for portraits and interiors, working alone in the attic. That is where I painted Rose."

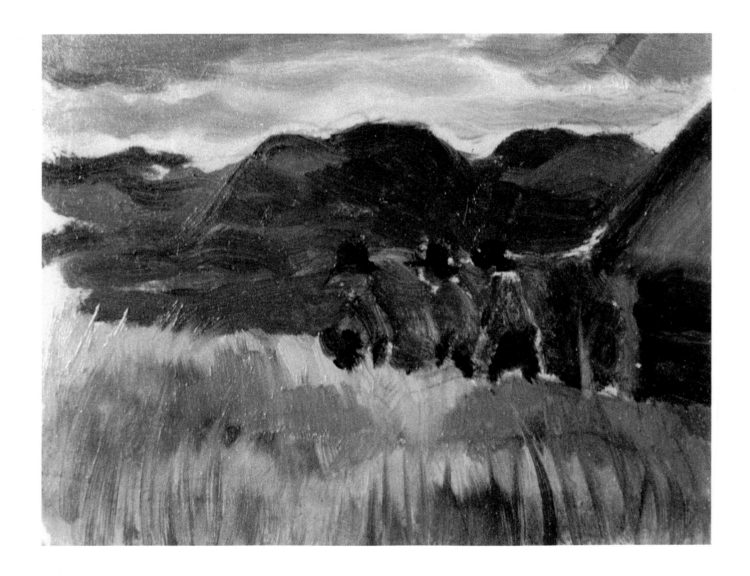

VI Jean Parlardy, *Autumn*, 1932, oil (24 x 30 cm). Private collection. Photograph by Maria Horyn. "Jean painted this one and others like it in a remarkably small size, mostly as designs."

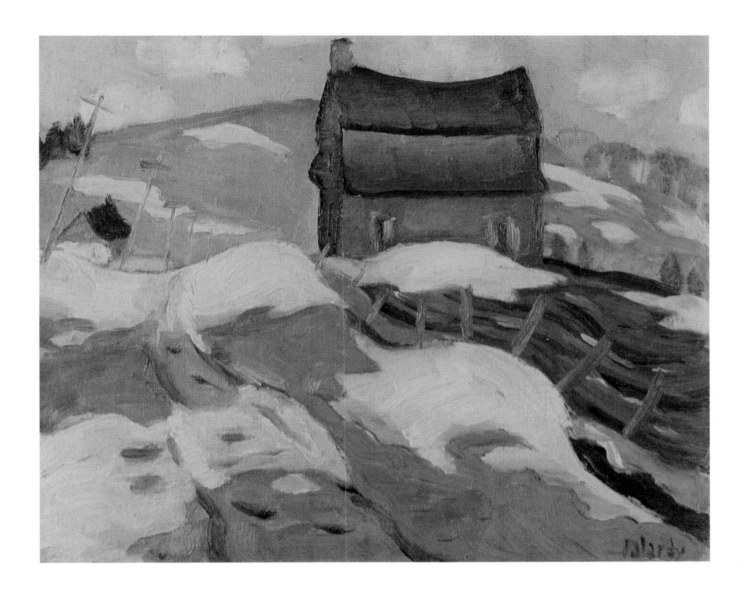

VII Jean Parlardy, *Plaques de neige, Blagouse, Les Eboulements*, 1932, oil on wood panel (18.3 x 23.3 cm). Private collection. Photograph by Maria Horyn. "Jean painted this while we were spending the winter with the family of Aquilas Girard. Down the hill leading to Les Eboulements was the Rang de Blagouse, so named by the Scottish Regiment stationed there years before because of a 'black house' at the end of the concession."

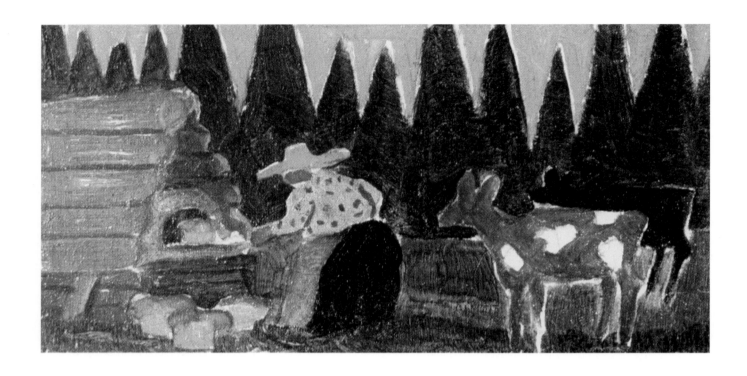

VIII Jean Parlardy, *St. Urbain de Charlevoix — Le four à pain*, n.d., oil (25 x 30.5 cm). Private collection. Photograph by Maria Horyn. "Jean made this as a design for a rug by Simone Mary Bouchard."

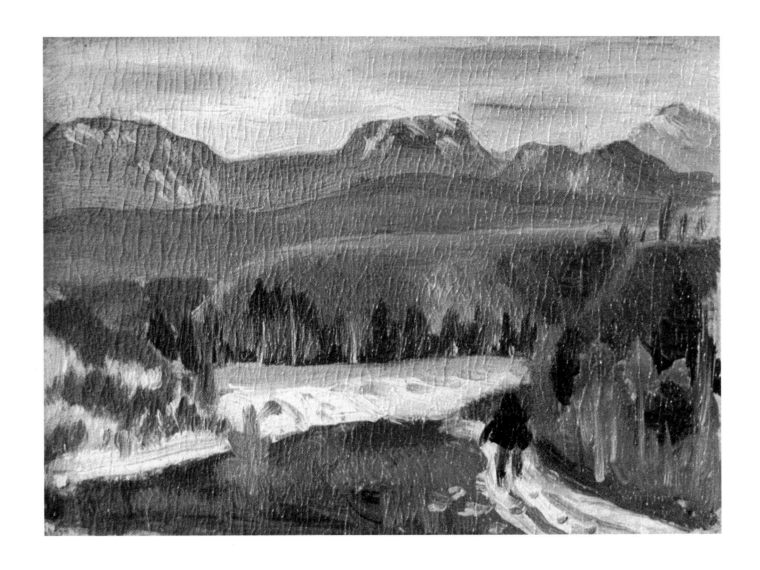

IX Jean Parlardy, *La Décharge, November 6, 1936*, 1936, oil (24 x 30 cm). Private collection. Photograph by Maria Horyn. "That figure is myself. Jean was standing before his easel and when I passed him he said, 'Stop a minute; I'll put you in it.' This was our first winter in Charlevoix County."

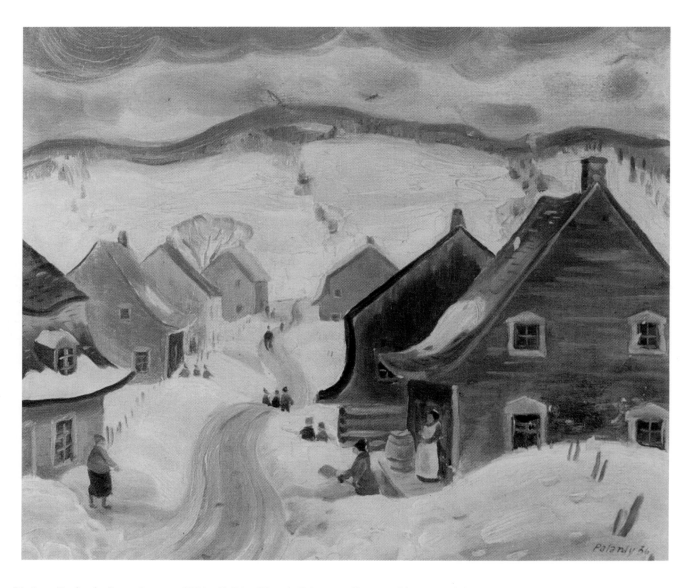

X Jean Parlardy, *La petite route,*1936, oil (24 x 50 cm). Private collection. Photograph by Maria Horyn. "It is a painting Jean did in Les Eboulements en Haut. Almost an A.Y. Jackson composition; I think Jackson did paint there also."

XI Jean Parlardy, *Harvest in Baie St. Paul*, 1937, oil (40.5 x 50.8 cm). Private collection. Photograph by Maria Horyn. "This is quite a large painting, actually an enlargement of a small sketch. He painted only 10 years, which I believe he deeply regretted later — until his passion for antiques inspired him to sit down one day and put together his wonderful book on Québec furniture."

XII Jean Parlardy, *Les Draveurs,* 1936, oil (7.5 x 13 cm). Private collection. Photograph by Maria Horyn. "This is a very small sketch, a design for a rug, which Simone Mary Bouchard used."

XIII Jean Palardy, *Décembre*, 1936, oil (24 x 30 cm). Private collection. Photograph by Maria Horyn. "Looking out of the window of Eloi Tremblay's kitchen, this is what we saw the morning of the first snow fall. That barn still exists, to my surprise, and one of Alice's daughters lives in the old house with all the modern conveniences."

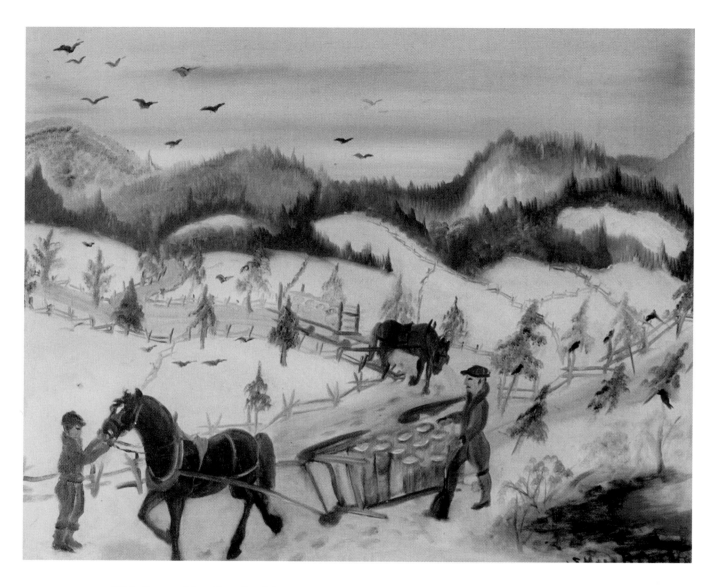

XIV Simone Mary Bouchard (1912-1945), *Paysage*, n.d. oil (38.3 x 47.3 cm). Collection of Dr. Joseph Stratford. Photograph by Maria Horyn. "The celebrated primitive painter we encouraged and saw frequently during our long periods in that Baie St. Paul area."